National Museums Scotland

SCOTLAND'S BEGINNINGS

SCOTLAND THROUGH TIME

Michael A Taylor and Andrew C Kitchener

National
Museums
Scotland

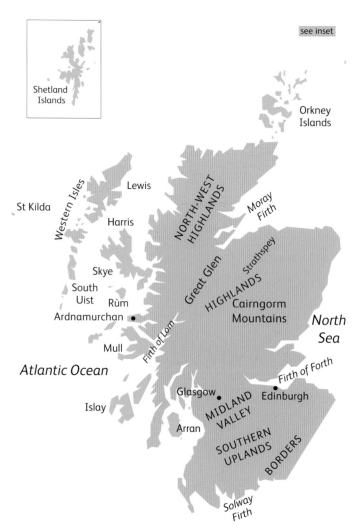

see inset

Shetland
Islands

Orkney
Islands

Western Isles

Lewis

St Kilda

Harris

NORTH-WEST
HIGHLANDS

Moray
Firth

Skye

Great Glen

Strathspey

South
Uist

Rùm

HIGHLANDS

Ardnamurchan

Cairngorm
Mountains

North
Sea

Mull

Firth of Lorn

Atlantic Ocean

Firth of Forth

Glasgow

Edinburgh

Islay

MIDLAND
VALLEY

Arran

SOUTHERN
UPLANDS

BORDERS

Solway
Firth

Published by NMSE – Publishing
a division of NMS Enterprises Limited
National Museums Scotland
Chambers Street
Edinburgh EH1 1JF

Text: © National Museums Scotland 2007, 2012

Illustrations/photographs:
© National Museums Scotland 2007, 2012
or © as individually credited 2007, 2012

ISBN: 978-1-901663-26-6

British Library Cataloguing in Publication Data
A catalogue record of this book is available from the British Library.

Cover design by Mark Blackadder.
Book design by NMS Enterprises Limited – Publishing.
Cover image of Isle of Arran (P & A Macdonald/SNH).
Printed by Ten Brink, Meppel, The Netherlands.

Published with the support of National Museums Scotland.

For full listing of NMS Enterprises Limited – Publishing titles and related merchandise:

www.nms.ac.uk/books

CONTENTS

PART 2 SCOTLAND'S WILDLIFE

IMAGE AND TEXT CREDITS

All images are credited individually on the page. Every attempt has been made to contact copyright holders. If any images have been inadvertently missed, please contact the publishers.

ROY ANDERSON:
www.habitas.org.uk/groundbeetles
page 52

BRITISH GEOLOGICAL SURVEY (BGS):
pages 10(x2), 13, 18(x2), 19, 20, 32, 36, 42, 43(x2), 46, 47

KATE CHARLESWORTH: page 25

CHASE STUDIOS INC: page 29

M I COATES: page 30

M COLLINSON: pages 51, 61(x3)

THE DRAWING ROOM:
pages 17, 21(x2), 27(x3), 28(x3), 45(x2), 47(x3), 67, 73, 77, 82(x2), 83, 84 (graphics)
pages 12, 15, 17, 21, 22, 27, 32, 36, 39, 41, 43 (global palaeomaps)
pages 41, 43, 53, 54(x2), 56, 64, 65, 67, 68, 71, 74, 78 (maps)

ENVIRONMENTAL RESEARCH CENTRE, UNIVERSITY OF DURHAM: pages 63, 69

GLASGOW CITY COUNCIL [MUSEUMS]: page 32

RICHARD HAMMOND: pages 23(x2), 24(x2) (models and photos)

GARY HINCKS: page 26

JOHN HOLMES: page 31 (model)

JEREMY HUNT: page 39 (model)

P & A MACDONALD: pages 9, 44(x2)

McMANUS GALLERIES AND MUSEUM, DUNDEE
page 25

NATIONAL MUSEUM WALES
(reproduced courtesy of): page 39

NATIONAL MUSEUMS SCOTLAND (NMS)
C Chaplin: pages 30, 31
Dept of Natural Sciences: page 25
L Florence: page 67(x2)
I Larner: page 45
N McLean: pages 45, 50, 51(x3), 53, 54(x2), 55(x2), 56, 57, 59(x3), 60, 61(x6), 62(x2), 64, 65(x2), 66(x2), 70, 72, 73, 75, 76, 77, 78, 79, 80, 82, 83, 84, 86
S Miller: page 11, 28, 43
NMS Photography: pages 12, 52, 53, 55, 56, 57, 58(x3), 60, 66, 67, 68(x4), 70, 71(x2), 76, 85
Scottish Life Archive (SLA):
page 33
K Smith: pages 45, 78
S Stevenson: pages 11(x3), 13, 15(x3), 17, 21, 22, 23(x3), 24(x3), 25(x2), 28, 29(x3), 33(x2), 37(x2), 39, 41; pages 31, 39 (photos of models)
M Sumega: pages 27, 28, 66, 72, 85, 86
L Taylor: pages 61, 62, 72, 75(x2), 83, 84, 86

NATURE PICTURE LIBRARY (NPL):
pages 14, 16, 49, 52, 57, 63, 71, 74, 80, 81(x2)

PARKS CANADA
T W Hall: page 58
W Lynch: pages 56, 58, 60

SCOTTISH NATURAL HERITAGE (SNH):
pages 11, 73, 74, 75, 76, 77(x2), 79, 81, 82, 83, 84, 85(x2)
L Campbell: page 80
L Gill: pages 69, 70, 72, 73, 75, 76, 77, 79, 82, 83(x2), 86
S Scott: page 76

JOHN SIBBICK: pages 20, 21, 22-23, 24, 34-35, 37, 38, 40

ANTHONY M SPENCER: page 15(x3)

G STEVEN AND T N TAIT, UNIVERSITY OF GLASGOW
page 58

J WILSON: page 85

TEXT AND DIAGRAM CREDITS

for pages 51 and 61(x3): P. D. MOORE, J. A. WEBB and M. E. COLLINSON: *Pollen Analysis* (Oxford: Blackwell Scientific Publications, 1991), 2nd edition, p. 216.

for page 31: Reproduced by permission of THE ROYAL SOCIETY OF EDINBURGH and T R SMITHSON, R L CARROLL, A L PANCHEN and S M ANDREWS in *Transactions of the Royal Society of Edinburgh: Earth Sciences*, vol. 84 (1994, for 1993), pp. 383-412.

for map data: Professor Ian Dalziel and Dr Lisa Gahagan, Plates Project, Institute for Geophysics, The University of Texas at Austin, Texas.

With thanks to Anthony Spencer for his help in producing this edition.

PREFACE

This book, like the National Museum of Scotland exhibition 'Beginnings' which inspired it, traces Scotland's journey across the globe, and the changes in its landscape and wildlife over the years. An astounding, even incredible, story: but the evidence is there in the rocks, which record the landscape and environment in which they were created, and the animals and plants which came to live there.

The book begins some 650 million years ago when Scotland – or what we now call Scotland – was under an iceberg-laden sea near the South Pole. Snapshots track Scotland's changing life and climate as it crept northwards, over the Equator, towards the North Pole – as it still does today. The changing climates, from cold through hot to cold again, explain why Scotland's rocks bear the remnants of subtropical rainforests, coral reefs and arid deserts.

The book then looks at the last few thousand years, after the glaciers melted to leave an empty land, and the wildlife which moved in as the climate warmed. To begin with, a few bands of roving hunters were the only people in Scotland.

The Scottish fossil record says little about the great mass extinctions, when most forms of life died out, at the ends of the Permian and later Cretaceous Periods. This is simply because we lack enough rocks of the right ages. But the fossil record is not required to study the latest great mass extinction of geological time: it is happening as we write.

Today's mass extinction began, for Scotland, some thousands of years ago when the hunters moved in. Like any new predator loose in a new land, they – it seems – exterminated large animals such as aurochs and elk.

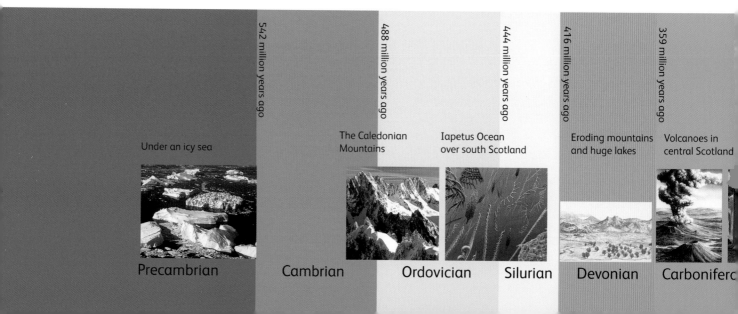

542 million years ago

488 million years ago

444 million years ago

416 million years ago

359 million years ago

Under an icy sea

The Caledonian Mountains

Iapetus Ocean over south Scotland

Eroding mountains and huge lakes

Volcanoes in central Scotland

Precambrian Cambrian Ordovician Silurian Devonian Carbonifero

(Over-hunting, in the form of over-fishing, continues even today.) Then the farmers took over the natural landscape, turning it to their own needs, and those of their hangers-on and pests. The expansion of modern farming, and creation of artificial hunting lands such as grouse moors, fragmented the remaining habitats of wild animals into small and isolated patches whose tiny populations often died out without natural recolonisation. Industrial pollution, population growth and urban expansion pushed habitat destruction further, and have now brought the new threat of global warming, with climate change and rise in sea levels.

One might think that if Scottish wildlife can survive the last few Ice Ages, with their violent climatic changes, then global warming is no problem. Nonsense! Wildlife survived only because ecosystems shifted north or south –

and upwards or downwards in altitude – to match the climate, at the speed with which plants could colonise new lands. That was possible only because the whole world was wilderness, and changes were still slow. Even then, many animals died out in Britain, or were never able to recolonise. And in today's world, where much of its wildlife lives in disconnected patches, the outlook for wildlife is bleak unless special provision is made for it.

But we hope this book will encourage you to explore books, websites, and museums – and, above all, Scotland's scenery – to see its wildlife and landscapes. The more people who come to treasure them, the more likely they are to survive.

Michael A. Taylor and Andrew C. Kitchener
EDINBURGH, 2007

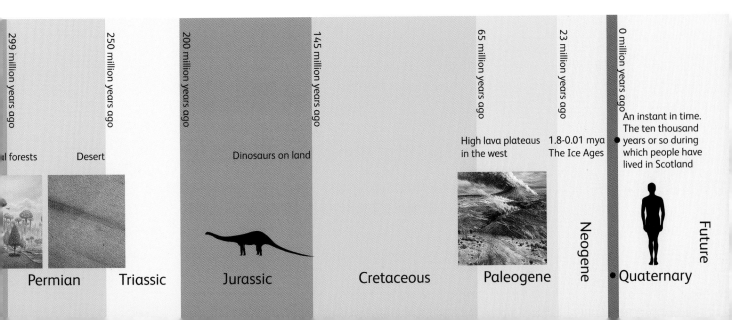

299 million years ago

250 million years ago

200 million years ago

145 million years ago

65 million years ago

23 million years ago

0 million years ago

…l forests Desert Dinosaurs on land

High lava plateaus in the west 1.8-0.01 mya The Ice Ages

An instant in time. The ten thousand years or so during which people have lived in Scotland

Permian Triassic Jurassic Cretaceous Paleogene Neogene Quaternary Future

PART 1

SCOTLAND'S JOURNEY ACROSS THE EARTH'S SURFACE

Michael A Taylor

INTRODUCTION TO PART 1

'The present is the key to the past'

North Berwick Law towers over the seaside town of North Berwick and the classic golfing and farming scenery of East Lothian. A peaceful scene – but evidence of massive change. The Law is the eroded remains of a volcano some 300 million years old. During the last million years or so glaciers flowed over the landscape, from right to left in the picture. They carved the landscape deeply, but left a 'tail' of softer rock in the lee of the Law whose hard volcanic rock was more resistant to erosion. As the ice melted, the land rose slowly as the weight of ice was removed. This lifted beaches out of the reach of the sea, creating a 'stepped' shoreline. Finally the wild natural forests were cleared to leave a man-made landscape.
(Photo: P & A Macdonald)

These are the words of the Scots geologist, Archibald Geikie (1835-1924). We know what Scotland was like at different times, from the evidence trapped in rocks and soils. This evidence might be the shell of a fossil animal, desert sands turned to stone, or the shape of a valley: all appear in this book. We can interpret this evidence from knowing how rocks and minerals are formed and destroyed today, and how animals and plants live now.

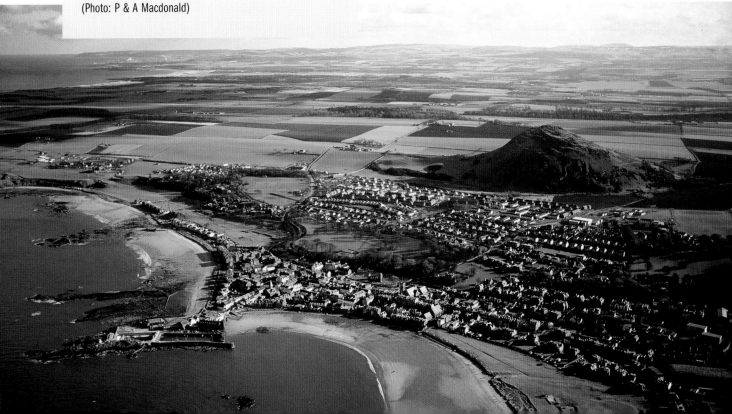

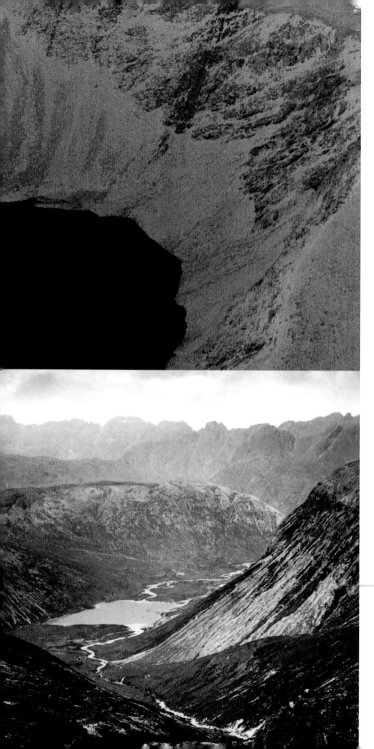

THE BUILDING BLOCKS OF TIME

ROCKS AND FOSSILS

Scotland's building blocks are the rocks, shaped by opposing forces – the forming of new rocks versus relentless erosion. Erosion breaks rocks down into gravel, sand grains and clay particles. These soils and sediments are washed and blown away, or sometimes even dissolved.

Erosion happens in different ways. The sea's beating waves prise open cracks in the rocks, and hurl and grind stones against them. Frost can break up rocks. Rainwater slowly dissolves some rocks, especially limestone.

Scotland is being slowly destroyed by erosion. Otherwise its mountains might be as high as the Himalayas. However, Scotland is continually being renewed by the formation of new rocks.

Above: Over the years ice has helped to form this scree in Coire an Lochain, Cairngorms, by shattering the rocks above. (British Geological Survey [BGS])

Left: The Cuillin Hills, Isle of Skye, in the distance. They were carved by tens of millions of years of erosion out of a huge reservoir of once molten rock that fed volcanoes. (BGS)

Sedimentary rocks are often recycled rocks formed from sediment – boulders, pebbles, gravel, sand and mud, the eroded remains of older rocks. Pebbles wear down to finer sediments, to gravel, then sand and mud. Rain, streams and rivers wash them down valleys, perhaps into lakes, perhaps into the sea. There they settle and maybe one day form new rocks. Some sedimentary rocks, especially limestones, form by chemical precipitation from water. Not all sedimentary rocks form under water. Wind-blown sand, for instance, can also become rock.

The remains of animals and plants are sometimes preserved as fossils. They often help to make up rocks, showing us evidence of what lived when the rocks were formed.

Igneous rocks were once molten, formed by great heat within the Earth. Sometimes the molten rock cools and solidifies within the Earth; or sometimes it erupts on the surface, as from volcanoes.

Metamorphic rocks were once buried so deeply that the original minerals making up the rocks were changed by great heat and pressure.

A sandy beach and dunes formed by wind and waves. (Scottish Natural Heritage [SNH])

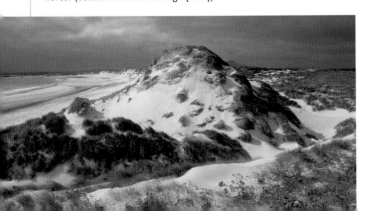

Conglomerate consists of naturally cemented sand and pebbles from older rocks. Unlike most Scottish rocks, this particular conglomerate is very young, around 10,000 years old. Its pebbles and sand were left by a river fed by melting ice at the end of the last Ice Age. Quaternary conglomerate from near Doune, Perthshire. (S Stevenson/NMS)

A rock transformed. This rock was once layers of sand and mud. When it was buried deeply, around 650 million years ago, the rock minerals were changed and the layers squeezed and folded. Moine Schist, Glen Carron. (S Miller/NMS)

Section cut through the 'Mussel band', from Ratho, Midlothian, a rock largely made from the shells of dead animals. This limestone contains the shells of mussels which lived in Carboniferous times over 300 million years ago. (S Stevenson/NMS)

Dark igneous rock (borolanite) in light grey marble, from Ledmore, Assynt, Sutherland. The dark rock was molten when it forced its way into cracks in the marble over 400 million years ago. You can see how it cuts across the marble. (S Stevenson/NMS)

The 'map' above shows Scotland's path on the face of the Earth over the last 650 million years (north to top).

mya = million years ago

The Scot James Hutton (1726-97) was the first scientist to realise how very, very long geological time is. The oldest Scottish rocks are about 3400 million years old, but the evidence they hold is very scanty. There is much more evidence for the last 650 million years of Scotland's history, the period on which we will focus in this book.

Global palaeomaps

The 'map' above shows a simplified version of Scotland's path across the face of the Earth over the last 650 million years (north to top). There are maps like this throughout this section, showing where Scotland was on the face of the Earth at particular times during its journey. The Earth's crust is made up of plates which move around on its surface, carrying continents with them. This movement is very slow, slower than it takes a fingernail to grow; but it all adds up over geological time.

Scotland, or rather the part of the Earth's crust we now call Scotland, did not always look like it does now. It had a different shape, and often it was partly or even wholly under the sea. 650 million years ago the land that was to become Scotland was far to the south, nearer the South Pole than the Equator. Since then it has wandered largely northwards through the tropics to where it is today. In this book you will find icecaps followed by subtropical coral reefs, and dry deserts followed by glacial ice once again.

The geologist James Hutton by the cartoonist John Kay, 1787. The artist has mischievously drawn the rocks to resemble the heads of Hutton's opponents as seen from the side. (NMS)

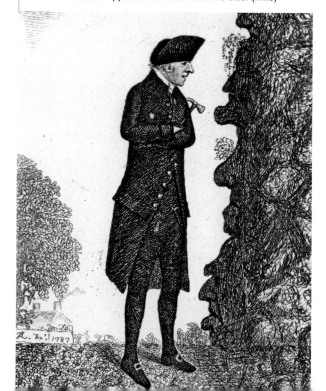

12

THE OLDEST ROCKS

LEWISIAN GNEISS

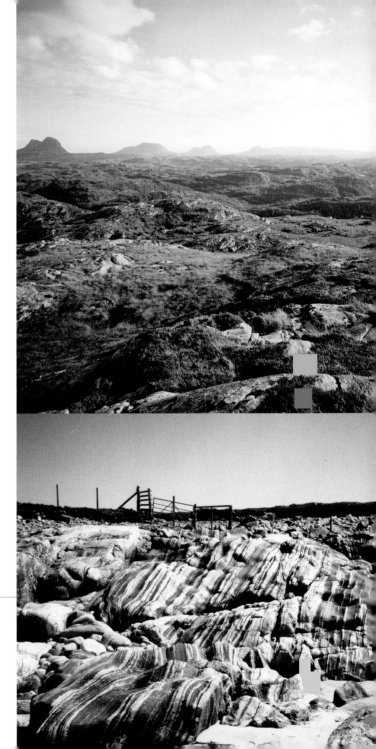

In the rocks called the Lewisian Gneiss, Scotland's history emerges from the depths of time. These ancient rocks are found in western and north-western Scotland. The oldest parts, in the North-West Highlands, are 3400 million years old: they are Europe's oldest known rocks, and the first evidence for Scotland's earliest history. Anything older has been destroyed over time (or perhaps is still buried).

This particular part of the Lewisian Gneiss on South Uist (right, below) is 2900 million years old. Originally it was igneous rock, which was then buried about 40 kilometres deep, where it underwent enormous pressures and very high temperatures, 800-1000°C. As a result the minerals in the rock were recrystallised to give the prominent striping. Later metamorphism, yet more heat and pressure, distorted and emphasised the striping.

The story continues …

Later rocks tend to be better preserved. There is much more evidence for the last 650 million years of Scotland's history on which this book concentrates.

Above: Lewisian Gneiss, in the foreground, near Lochinver, Sutherland. The tough gneiss resists erosion well to give the typical scenery of small rocky knolls and small lochs. The mountains in the distance are mostly of younger Torridonian Sandstone. (BGS)

Right: Lewisian Gneiss on South Uist, Outer Hebrides. (S Stevenson/NMS)

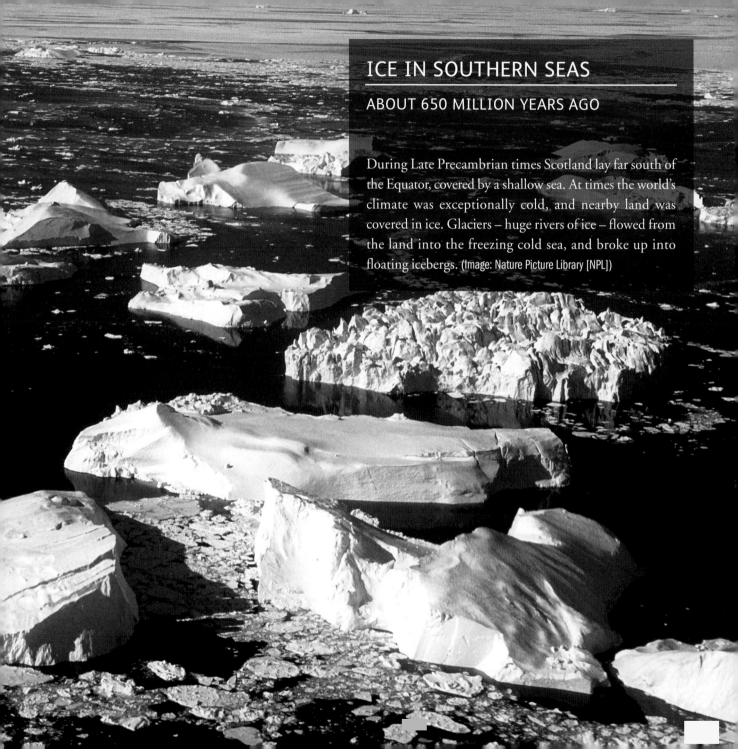

ICE IN SOUTHERN SEAS

ABOUT 650 MILLION YEARS AGO

During Late Precambrian times Scotland lay far south of the Equator, covered by a shallow sea. At times the world's climate was exceptionally cold, and nearby land was covered in ice. Glaciers – huge rivers of ice – flowed from the land into the freezing cold sea, and broke up into floating icebergs. (Image: Nature Picture Library [NPL])

Snowball Earth

In 1871 at Port Askaig, Isle of Islay, James Thomson suggested that some schistose rocks with embedded boulders of granite had been transported by the agency of ice. This was the first ever description of late Precambrian glacial strata. Such rocks have since been recognised in almost every continent and this widespread occurrence has led to the suggestion that the whole Earth was then covered with ice – an idea termed 'Snowball Earth'. On Islay and the Garvellach Islands, Firth of Lorn, the sequence of these glacial strata is also one of the most complete in the world – recording perhaps 17 glacial periods.

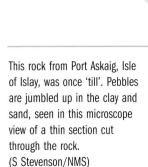

Scotland lay near the south pole.

650 mya

This rock from the Garvellach Islands, Firth of Lorn, was once 'till' – clay, sand, pebbles and boulders picked up by an ice sheet as it flowed over land. When the ice reached the sea it floated as an ice shelf or glaciers – finally breaking up into icebergs. The tills were deposited by the melting of the ice on the coastal plain and shallow sea floor. (A Spencer)

Polygonal sandstone wedges seen looking down onto the top surface of one of the 'till' beds, on the island of Eileach an Naoihm, Garvellach Islands. The polygons may have formed as contraction cracks during seasonal changes in temperature on a frozen coastal plain. (A Spencer)

This rock from Port Askaig, Isle of Islay, was once 'till'. Pebbles are jumbled up in the clay and sand, seen in this microscope view of a thin section cut through the rock. (S Stevenson/NMS)

Ikaite, a fossil 'thermometer', from the Garvellach Islands, Firth of Lorn. The spiky shapes in the rock may once have been crystals of ikaite, a mineral which exists only in icy cold water, below 3°C. Later it was replaced by other minerals, quartz and dolomite, leaving the original shape. (S Stevenson/NMS)

15

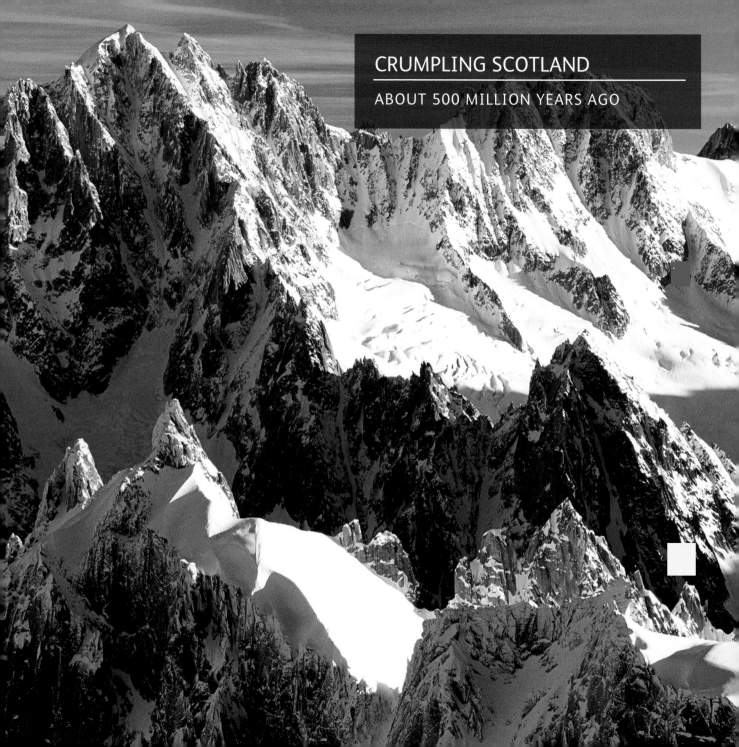

CRUMPLING SCOTLAND

ABOUT 500 MILLION YEARS AGO

The great mountains

The Caledonian Mountains took more than 100 million years to form. About 500 million years ago, late in the Cambrian Period, Scotland lay on the southern edge of a large continent, submerged under the shallow northern margin of the deep, wide Iapetus Ocean.

The Earth's crust was moving northwards, diving deep into the Earth under Scotland in a process called subduction. Scotland was compressed from the south towards the north. Very slowly, with millions of earthquakes, it crumpled. The rocks of Scotland often show the effects of this squeezing. Layers that were once flat are now completely contorted.

Over millions of years, as Scotland was compressed, the land rose from under the sea to become the huge Caledonian Mountains. These mountains would have been as high as the Alps today, perhaps even as high as the Himalayas. Four hundred million years of erosion by rain, sun, wind, and ice and frost, destroyed them. Only their deep roots remain, and these roots now form the Highlands.

One piece of evidence that many of the rocks of the Highlands were once deeply buried is the granite found in the Cairngorms and elsewhere in the Highlands. This rock was formed some 400 to 500 million years ago, when huge masses of molten rock crystallised into solid granite deep beneath the Caledonian Mountains, but it is now exposed by erosion.

Scotland moves slowly north.

500 mya

650 mya

Rock layers, once flat, but now crumpled by Earth movements. Folded mica schist from Lochan na Lairige, near Killin, Perthshire. (S Stevenson/NMS)

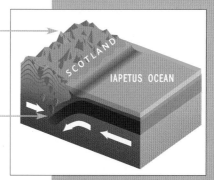

The Caledonian Mountains forming as Scotland crumples.

SCOTLAND

IAPETUS OCEAN

Part of the Earth's crust diving under Scotland.

Scotland was once like this. The Caledonian Mountains took more than a hundred million years to form. (NPL)

17

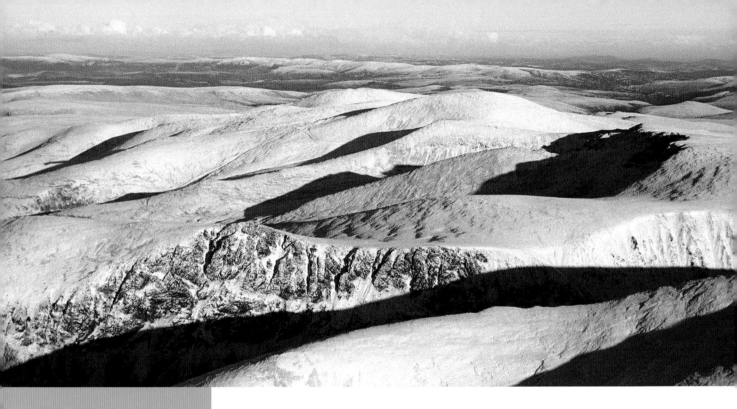

The Cairngorm Mountains. Their hard granite rock resists erosion well to give character-istically rounded mountains. (BGS)

Scotland did not just crumple – it also tore. Great 'faults' ran right across the country. Along these faults the different parts of Scotland moved past each other, vertically, horizontally, and sometimes both. For instance, the Great Glen Fault runs through Shetland, down the Great Glen from Inverness to Fort William and out past Mull. Movement along the fault shattered the rocks along it, making them less resistant to erosion. This resulted in the Great Glen which is now flooded with a string of lochs, including Loch Ness and Loch Lochy.

Making model mountains. Scots geologist Henry Cadell (1860-1934), simulating the formation of mountains by squeezing layers of clay in a vice, 1887. (BGS)

Looking north-east along the Great Glen towards Loch Lochy. (BGS)

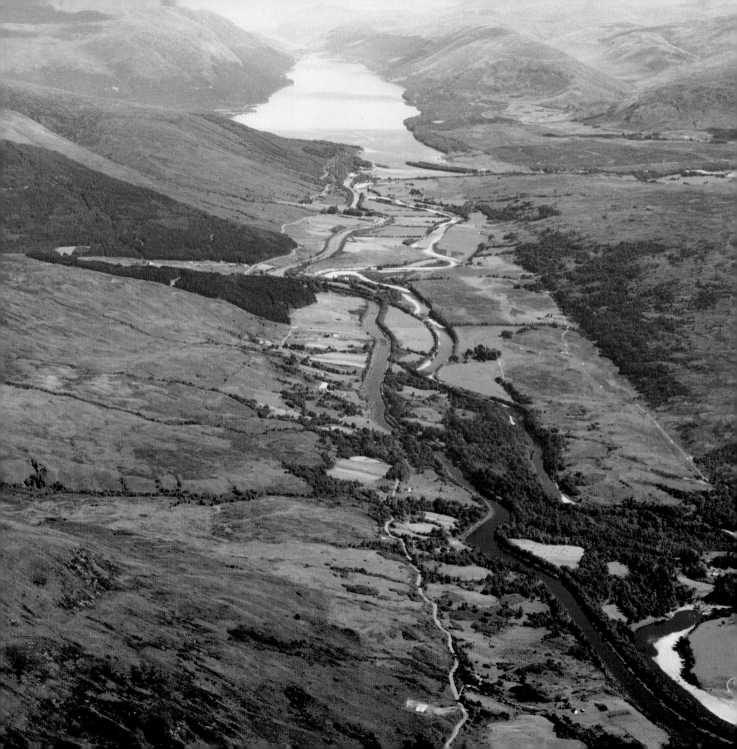

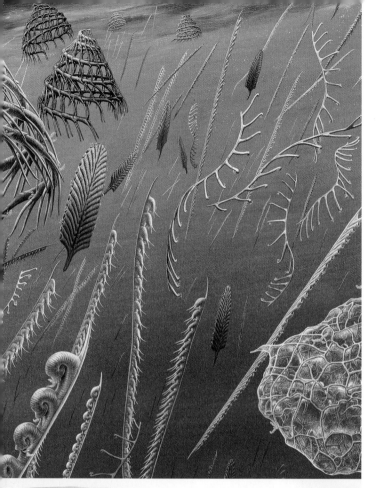

THE VANISHING OCEAN

ABOUT 440 MILLION YEARS AGO

During the Ordovician and Silurian Periods the climate was warm and tropical. Scotland was moving northwards, joined to what are today North America and Greenland.

The wide, deep Iapetus Ocean separated Scotland from England, which was joined to what is Europe today. It was no mere flooding of the land by the sea, but a truly deep-water ocean, like the Atlantic today. Rivers brought sediment from the land down to the sea, but only the finer material was carried far out into the Iapetus. There it sank to the bottom, accumulating and forming rock over many millions of years.

Graptolites, now extinct, drifted in the upper waters of the open sea as jellyfish and plankton do today. When they died they sank to the sea floor and became buried in the mud. When this mud became rock, the graptolites were fossilised. Rock from the Iapetus Ocean floor contains lots of graptolites, but hardly any fossils of animals from shallow coastal waters – evidence that the Iapetus really was a deep ocean.

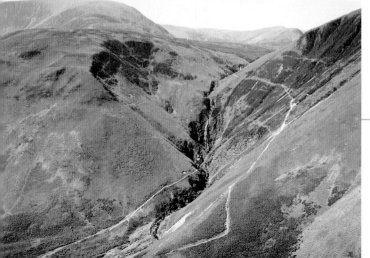

Above: Graptolites in the sunlit upper waters of the Iapetus Ocean, about 435 million years ago in the Silurian Period. (Painting: J Sibbick)

Left: The Grey Mare's Tail water-fall in Moffatdale, Dumfriesshire. The Border hills were once mud on the floor of the Iapetus Ocean. (BGS)

As the floor of the Iapetus Ocean was subducted beneath (taken under) the northern continent, the ocean slowly narrowed by a few centimetres each year.

Subduction continued over millions of years. Layers of sediment were scraped against the edge of the continent and crumpled into great folds. Today these folded rocks form the Southern Uplands, the sparsely populated hills making a natural frontier zone between Scotland and England.

The Iapetus finally closed about 425 million years ago. The continents collided, forming one huge continent. In the middle lay Scotland and England, now joined.

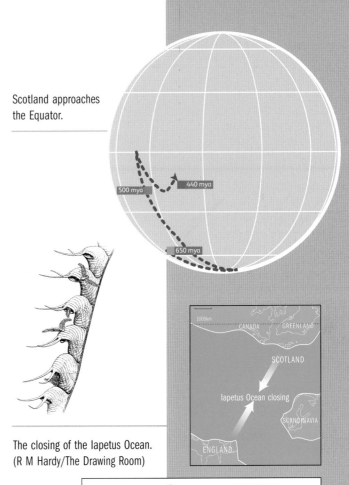

Scotland approaches the Equator.

500 mya 440 mya 650 mya

The closing of the Iapetus Ocean.
(R M Hardy/The Drawing Room)

CANADA GREENLAND SCOTLAND Iapetus Ocean closing SCANDINAVIA ENGLAND 1000km

Graptolites, *Leptograptus capillaris*, from near Moffat, Dumfriesshire. The name 'graptolite' comes from the Ancient Greek words *graptos* meaning marked with writing, and *lithos* meaning stone. This is because graptolites look so much like pencil marks on slate, as if someone has scribbled all over the rock. (S Stevenson/NMS)

Right: Each graptolite was a whole colony of little animals. They lived in rows in a horny communal shell. They fed by catching tiny particles in comb-like sieves. This drawing shows part of one graptolite colony, larger than life. (Illustration: J Sibbick)

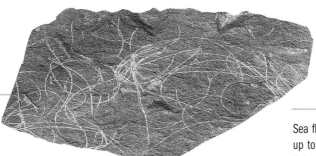

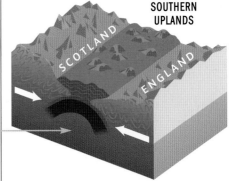

SOUTHERN UPLANDS

SCOTLAND ENGLAND

Sea floor mud crumpled up to form the Southern Uplands.

21

EARLY LAND AND LAKE LIFE

ABOUT 410 MILLION YEARS AGO

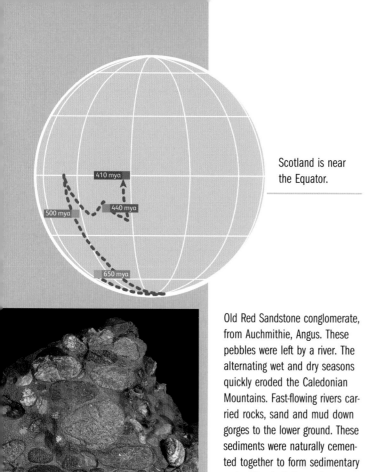

Scotland is near the Equator.

During the Devonian Period, Scotland was near the Equator. The climate was hot and dry, with torrential seasonal rains, rather like northern India and Pakistan today. The Caledonian Mountains were quickly eroded.

Life in lakes

Lakes in the lowlands were full of early fish and other animals. While the Old Red Sandstone was being laid down from about 420 to 360 million years ago, its sediments trapped the fossils of animals that lived in the lake waters. They record a tremendous evolutionary change. At first there were many early jawless fish (agnathans, most now extinct) such as *Zenaspis*, with giant eurypterids or 'water-scorpions' such as *Pterygotus* (over one metre long) preying upon them.

Old Red Sandstone conglomerate, from Auchmithie, Angus. These pebbles were left by a river. The alternating wet and dry seasons quickly eroded the Caledonian Mountains. Fast-flowing rivers carried rocks, sand and mud down gorges to the lower ground. These sediments were naturally cemented together to form sedimentary rocks. They include mudstones, sandstones and conglomerates, together known as the Old Red Sandstone. (S Stevenson/NMS)

But soon the jawed fish took over, with their more efficient mouths. Some, like *Pterichthyodes*, had armoured heads and bodies (placoderms, all now extinct). Others were acanthodians, recognisable by the single spine which supports each fin like a mast and sail: these are all now extinct. Finally there were various bony fishes, such as *Tristichopterus* whose relatives include the amphibians which gave rise to reptiles, birds and mammals.

The eurypterid or 'water-scorpion' was a top predator, seizing prey with its pincers. This fossil is the hard shell of the head, body and tail, probably cast off when the animal moulted during growth. *Pterygotus anglicus* from Carmyllie, Angus. (S Stevenson/NMS)

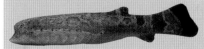

Turinia, another agnathan (jawless fish), had a flattened underside so it could lie on the lake floor and perhaps hide in the sand and mud. It scooped up the mud and sieved out edible particles such as small worms and bits of dead animals and plants. This fossil is seen as if lying on its back, and the model is seen from the side. From Turin Hill, near Forfar, Angus. (Fossil: S Stevenson/NMS; model and photo: R Hammond)

With its simple mouth *Zenaspis* (fossil above, and model below), an agnathan (jawless) fish, probably foraged for bits of food, worms and other soft-bodied animals on the lake floor. This fossil is lying on its back, showing the belly and the inside of the head armour. From Carmyllie, Angus. (Fossil: S Stevenson/NMS; model and photo: R Hammond)

Below: Scotland in Devonian times. The land is mostly dry, but with early plants growing beside lakes fed by seasonal rivers. In the distance are the Caledonian Mountains. (Illustration: J Sibbick)

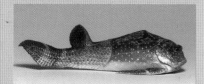

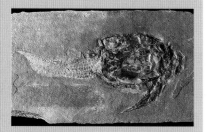

Pterichthyodes (life model and fossil), a placoderm (armoured) fish, had eyes and nostrils on top of its head, and a flat belly. It probably lived on the lake floor, walking on its stilt-like bone-covered forefins, eating mud and digesting any small animals or particles of food. From Achanarras, Caithness. (Model and photo: R Hammond; fossil: S Stevenson/NMS)

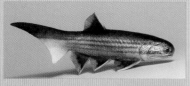

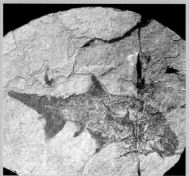

Cheiracanthus (life model and fossil), an acanthodian (spiny) fish, lacked teeth. Instead, it was a filter feeder. It swam with its mouth open, pumping water through its gills, and straining out food particles with well-developed gill rakers (bony rods supporting the gills). From Tynet Burn, Banffshire. (Model and photo: R Hammond; fossil: S Stevenson/NMS)

Meanwhile, on land ...

In Devonian times simple plants grew around lake edges and where the ground was damp.

Animals such as millipedes lived amongst the mosses and taller plants. The taller plants could grow higher than the mosses because they had stronger stems with channels to bring water from the roots to the green shoots. Like mosses and ferns today, these plants spread by tiny spores rather than seeds.

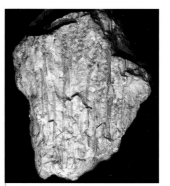

A clump of shoots of *Zosterophyllum*, from near Forfar, Angus (fossil, left). This plant had green shoots but no leaves. It probably grew in shallow water as reeds do today. The round objects on the end of the stem are the sporangia, where the spores developed, and from which they were shed. *Zosterophyllum* has no close living relatives. (Fossil: S Stevenson/NMS; illustration: *Zosterophyllum* in life, by J Sibbick)

One way fossils are formed
(see diagram below)
[Illustration by Kate Charlesworth]

1. At the end of the dry season a small lake starts to dry up.
2. The lake is almost dry. The fish are crowding into the water that is left.
3. The fish die and wind-blown sand covers them.
4. At the return of the wet season more sand is washed over the fish. This sand turns to rock.
5. Fossil hunters excavate the fossils many millions of years later.

1

2

3

4

5

A plant frond from a land plant, perhaps washed down river into a lake where it fell to the lake bottom and was buried next to a fish. The fish is a sarcopterygian (lobe-finned) fish, *Tristichopterus*. From South Ronaldsay, Orkney. (S Stevenson/NMS)

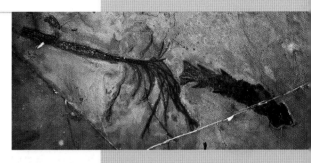

This millipede, *Kampecaris*, ate dead plant material just as garden millipedes do today. From Balruddery Den, Perthshire. (Photo: S Stevenson/NMS; fossil: McManus Galleries and Museum, Dundee)

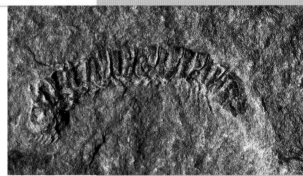

A pond which dried up 370 million years ago. This is part of a famous fossil 'graveyard' of fish found at Dura Den in Fife. (Dept of Natural Sciences/NMS)

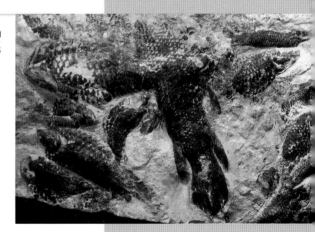

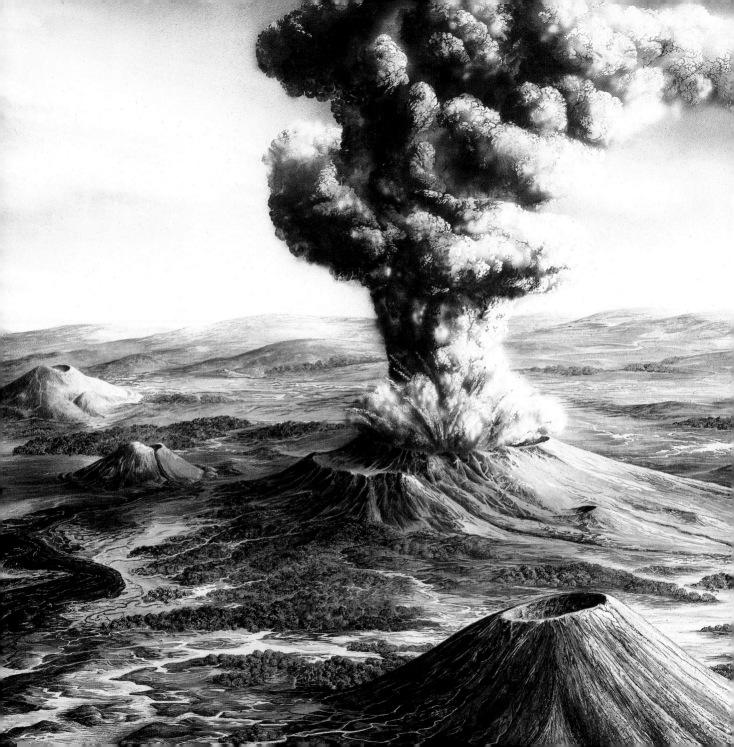

VOLCANOES

ABOUT 340 MILLION YEARS AGO

Early in the Carboniferous Period, about 340 million years ago, Scotland was near the Equator, part of a single huge continent. The climate was hot and wet, with fluctuating sea levels. What is now the Midland Valley of central Scotland had a landscape of volcanic hills, lakes and low coastlands. Coral reefs, teeming with life, grew in the warm shallow seas. Volcanoes dominated the scenery of central Scotland. In irregular bursts of activity they ejected molten lava and powdery ash. Today their remains still dominate the landscape.

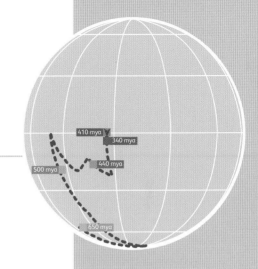

Scotland near the Equator.

Left: The formation of Edinburgh Castle Rock.

Below: Edinburgh Castle, sitting on the remains of a volcano. (M Sumega/NMS)

Edinburgh Castle Rock was once a volcano, but it has been shaped by erosion. You see not so much the original volcano but the blockage in its plumbing. When the volcano stopped erupting, the molten rock in the feeder channel cooled and hardened, forming basalt rock. The basalt was harder than the rocks around it, so it resisted erosion more. Today it is left as a dramatic isolated hill.

Edinburgh, 340 million years ago. (Painting: G Hincks)

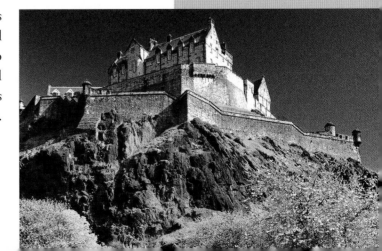

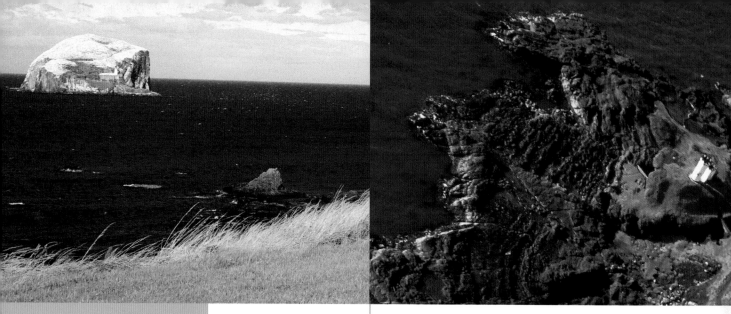

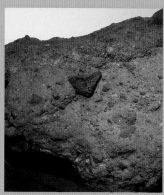

Above: The Bass Rock is the remains of a volcano, rising sheer from the Firth of Forth opposite Tantallon Castle. Once a prison island, it is now a huge gannet colony.
(M Sumega/NMS)

The rock (far left, lower) was collected from this volcanic vent at Elie Ness (above). You can see the centre of the volcano through which the lava originally erupted, now choked with rock.

The sea has cut across the conical layers of lava that formed the cone of the original volcano, to give the rings on the shore.
(S Miller/NMS)

Above is vent agglomerate, from Elie Ness, Fife, some of the rock that blocked the neck of a dying volcano.
(S Stevenson/NMS)

When the Elie Ness volcano stopped erupting, lava and ash, mixed with pieces of the surrounding rock, fell back into the neck.

They were then welded together by the heat to form igneous rock.

Erosion cuts across the layers to give the striped appearance seen today.

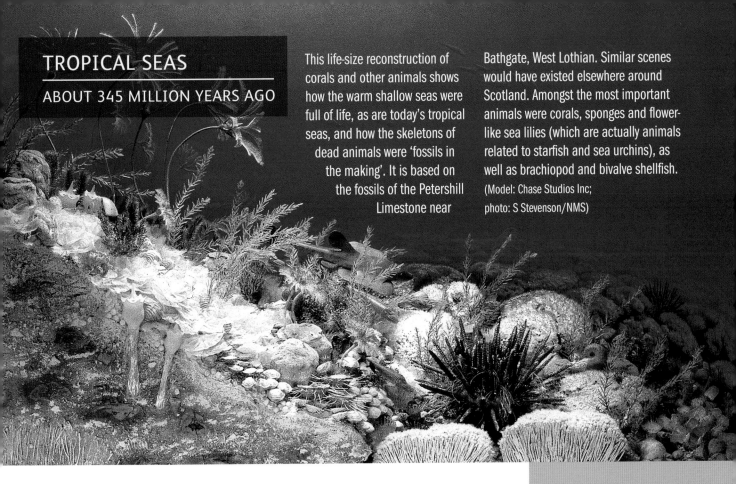

TROPICAL SEAS

ABOUT 345 MILLION YEARS AGO

This life-size reconstruction of corals and other animals shows how the warm shallow seas were full of life, as are today's tropical seas, and how the skeletons of dead animals were 'fossils in the making'. It is based on the fossils of the Petershill Limestone near Bathgate, West Lothian. Similar scenes would have existed elsewhere around Scotland. Amongst the most important animals were corals, sponges and flower-like sea lilies (which are actually animals related to starfish and sea urchins), as well as brachiopod and bivalve shellfish.
(Model: Chase Studios Inc; photo: S Stevenson/NMS)

Part of a colony of the coral, *Lithostrotion*. Many individuals lived together, each in its own section of one big limy skeleton, rather like flats in a tenement block. Corals are related to sea anemones and, like them, catch small animals with their tentacles.
(S Stevenson/NMS)

A bivalve shellfish, *Limipecten*.
(S Stevenson/NMS)

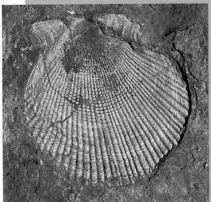

FOSSILS

EAST KIRKTON – A SNAPSHOT IN TIME

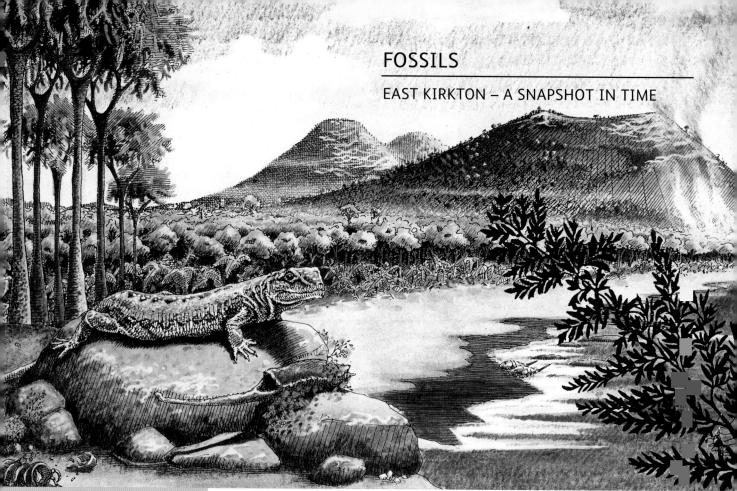

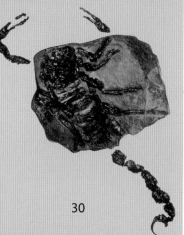

East Kirkton, 330 million years ago. (Illustration: M I Coates)

Pieces of a 70cm-long fossil scorpion, *Pulmonoscorpius*, found at East Kirkton. They lived on land and hunted anything they could catch, perhaps amphibians or other scorpions. (C Chaplin/NMS)

The fossils of a tiny nineteenth-century quarry at East Kirkton, near Bathgate, West Lothian, give a rare insight into early land life. The quarry was rediscovered in 1984 by Mr Stan Wood, the professional fossil collector. Later an excavation project led by National Museums Scotland (NMS) took place, with the co-operation of owners, West Lothian District Council.

East Kirkton is an unusual deposit because most of its fossils are of land animals rather than those which lived in water. 330 million years ago a small lake was fed by

volcanic hot springs rich in dissolved chemicals. These chemicals were deposited as layers of rock on the bottom of the lake, preserving fossil animals and plants. Fossils of water-living animals are rare, probably because the lake was hot or poisonous. Most fossils are of land-living animals and plants, or water-living animals which were, at the very least, amphibious – they could live on land as well as in water. Finds include newt-like amphibians, giant eurypterids or 'water scorpions', proper scorpions and harvestman spiders, as well as various plants and animals shown here.

Lizzie – a Very Important Fossil

This fossil became famous as 'Lizzie the Lizard' when NMS acquired it by public appeal in 1990, as it was then thought to be the oldest known reptile, possibly even the ancestor of all other reptiles, birds and mammals (including humans). It has been formally named *Westlothiana lizziae* in honour of its origins and rather misleading nickname (it is not a lizard at all).

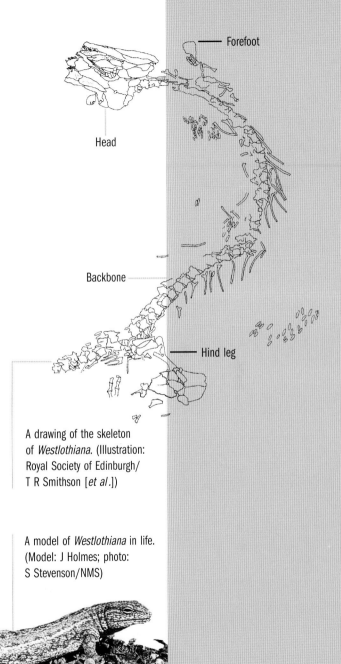

Forefoot

Head

Backbone

Hind leg

A drawing of the skeleton of *Westlothiana*. (Illustration: Royal Society of Edinburgh/ T R Smithson [*et al*.])

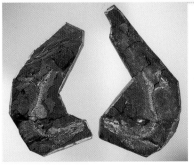

'Lizzie', the first specimen of *Westlothiana lizziae*. (C Chaplin/NMS)

A model of *Westlothiana* in life. (Model: J Holmes; photo: S Stevenson/NMS)

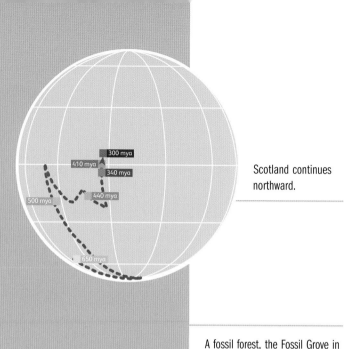

Scotland continues northward.

TROPICAL COAL FORESTS

ABOUT 300 MILLION YEARS AGO

Later in the Carboniferous Period, Scotland lay almost on the Equator. The climate was warm and wet, and tropical forests grew on the plains. Large river systems shifted back and forth across the coastal plains and branched out to meet the sea, forming deltas.

Coal

Coal was formed in seams. Each seam is the remains of forests that were flooded as sea levels rose, and buried under the sand and mud deposited by the deltas along the coast. As water levels fell, new forests grew on top.

This sequence of events happened again and again, building up huge thicknesses of Coal Measures rocks.

A fossil forest, the Fossil Grove in Victoria Park, Glasgow. Stumps of scale-trees remain fossilised where they once grew. The giant scale-trees (lycopsids) were the tallest forest plants; some grew to over 40 metres high. They are extinct today; their only living relatives are the tiny quillworts. (Glasgow City Council [Museums])

Coal seams in Blindwells Opencast Mine, near Tranent, East Lothian. (BGS)

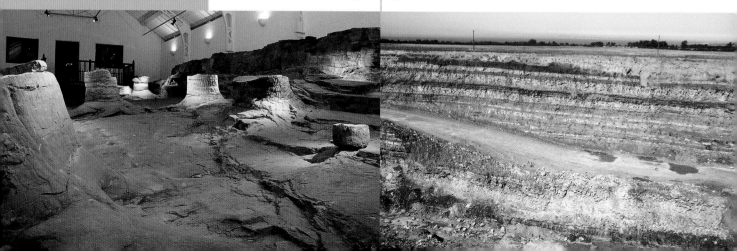

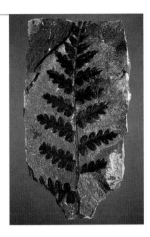

The frond of the seed-fern *Mariopteris*, from Whiterigg, Airdrie. The seed-ferns (pteridosperms) grew up to 10 metres tall and had fern-like fronds. They were not true ferns, and are extinct today. They were the first plants to spread by seeds rather than spores.
(S Stevenson/NMS)

Powering the Industrial Revolution

Victorian Scotland, one of the world's first industrialised nations, was powered by coal: in other words, by the solar energy that was captured by the giant Carboniferous forests and then locked up in the coal.

The Industrial Revolution depended on iron as well, especially from the rich 'blackband' ironstone, formed from iron minerals deposited in the Carboniferous swamps.

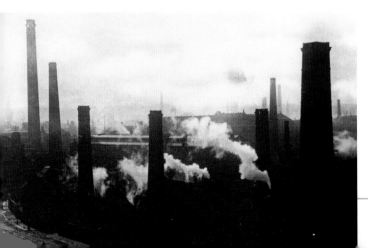

How coal forms

1 Leaves, twigs and dead trees build up on the forest floor.

2 The forests are flooded. The remains of the trees are buried in sand and mud.

3 The weight of the sand and mud squeezes out the water and squashes the remains of the trees.

4 Over millions of years the remains of the trees become coal.

5 The coal is dug out in mines.

Coal, once the remains of a forest, from Chalmerston Opencast Mine, Ayrshire.
(S Stevenson/NMS)

A coal-burning scene, typical of industrial Scotland until well into the 20th century.
(SLA/NMS)

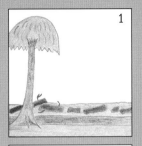

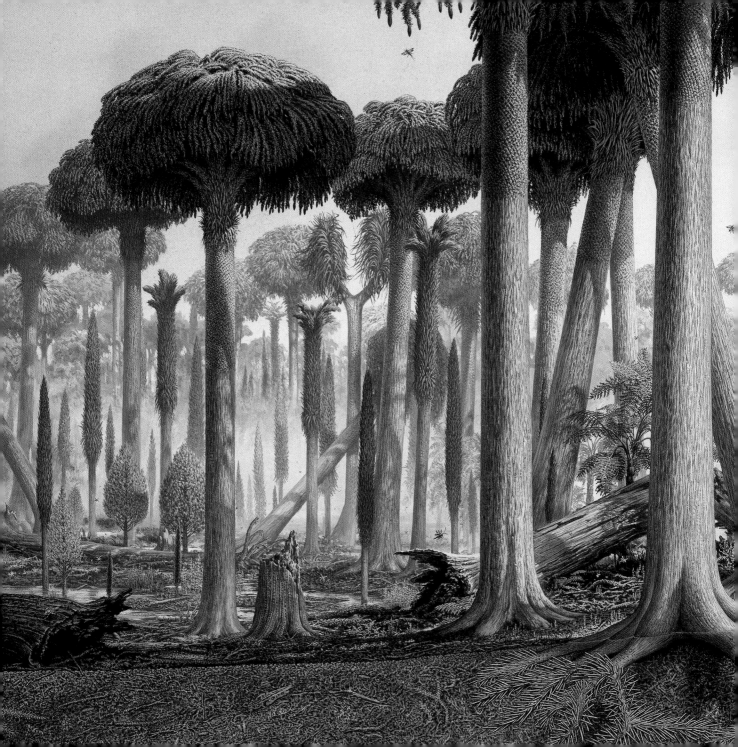

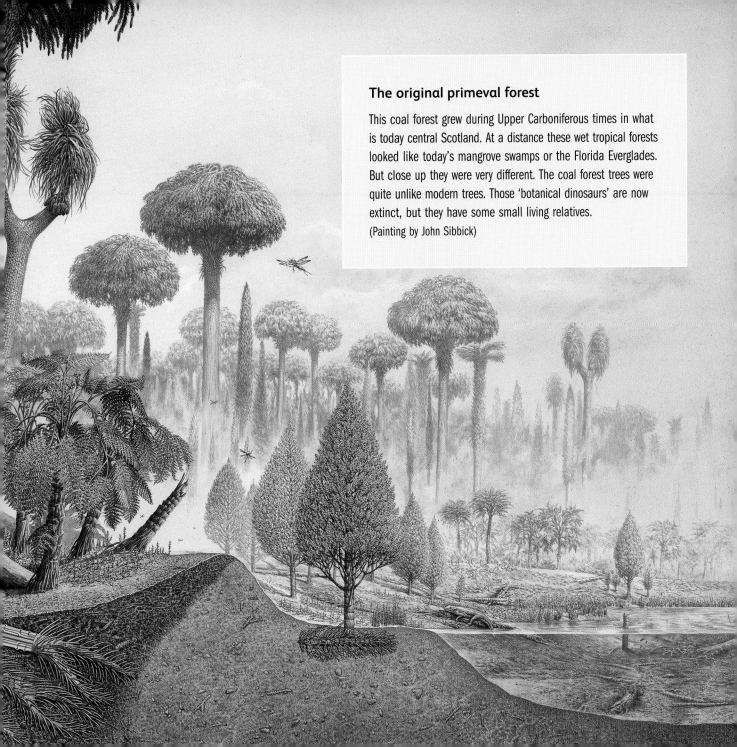

The original primeval forest

This coal forest grew during Upper Carboniferous times in what is today central Scotland. At a distance these wet tropical forests looked like today's mangrove swamps or the Florida Everglades. But close up they were very different. The coal forest trees were quite unlike modern trees. Those 'botanical dinosaurs' are now extinct, but they have some small living relatives.
(Painting by John Sibbick)

THE GREAT SCOTTISH DESERT

ABOUT 260 MILLION YEARS AGO

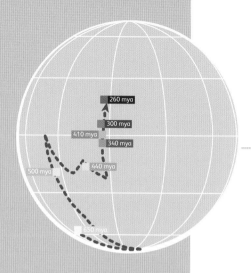

Scotland continues north, but is still near the Equator.

During the Permian Period, Scotland was just north of the Equator. The climate was hot and dry, and Scotland was mostly desert, like the Sahara and Arabia today. Some areas were covered by huge sand-dunes. There were a few temporary rivers and salty lakes. The desert climate continued for tens of millions of years, into the following Triassic Period.

Where loose sand covered the desert, the wind sometimes blew it into huge dunes. This rock face, seen at Ballochmyle Quarry, Ayrshire in 1921, cuts across several fossil sand dunes, one on top of another. The way in which such fossil dunes are aligned in south-western Scotland shows that the prevailing wind 260 million years ago was north-easterly. (BGS)

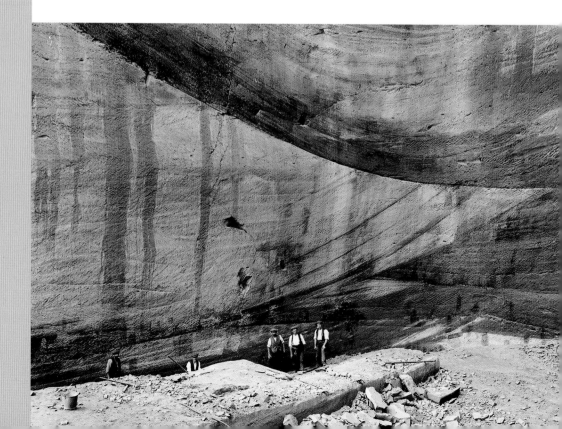

Footprints in the sands of time

The animals of the desert are known mostly from footprints such as those below from Corncockle Muir, Dumfriesshire, because fossil bones are very rare in these rocks. This is not surprising as deserts are harsh and dry places and bones tend to crack and break up before they can be fossilised.

However, from scarce finds of bones, it seems that among the reptiles that made these footprints were ones of a type known as dicynodonts. The painting below shows a small dicynodont, less than one metre long.

Dicynodonts

Dicynodonts ate plants with their horny beaks. They probably used their tusks for threatening and fighting other dicynodonts, and defending themselves from meat-eating reptiles. How did they find their food in the desert? Perhaps they went to fertile areas next to rivers or springs where plants grew. Maybe the fossil footprints below were made by animals walking over the desert to look for water or food. Dicynodonts would also eat any plants growing after seasonal or occasional rains.

A dicynodont, and, below this, some fossil footprints, possibly left by a dicynodont. (Illustration: J Sibbick; footprints, photo: S Stevenson/NMS)

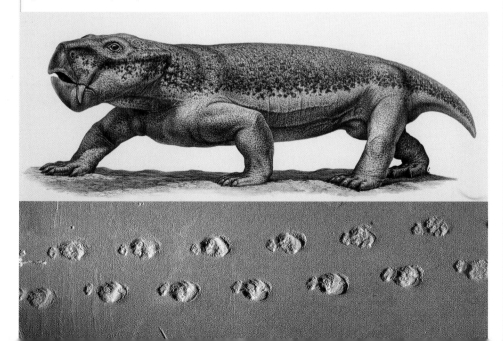

Above: The sand of the great Scottish desert! This sandstone rock is from Locharbriggs Quarry, in Dumfriesshire. It was once desert sand grains, which have since been naturally cemented together. (S Stevenson/NMS)

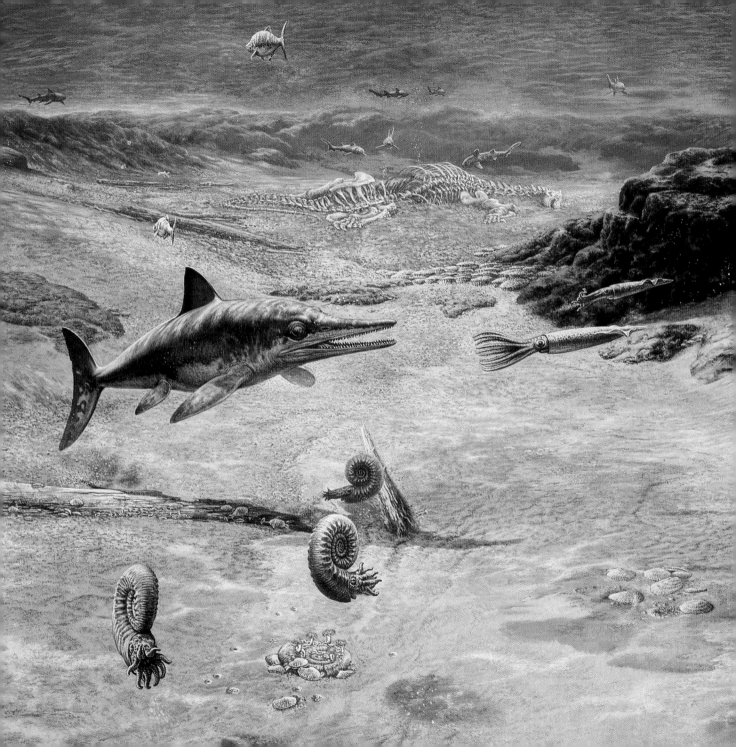

THE NEW SEAS

ABOUT 167 MILLION YEARS AGO

In the middle of the Jurassic Period, Scotland was beginning to take its modern shape. It lay in the middle of a giant continent, but around it blocks of the Earth's crust dropped along faults to create low-lying areas. The warm sea then flooded these areas. On the east lay what is now the North Sea. Later in the Period the crust split along faults and what is now the Atlantic Ocean began to form. We know the sea was full of life from the number of fossil sea creatures. Some of the most typical were the ammonites, shellfish related to today's squid, octopus and pearly nautilus. They were especially common and very varied.

Scotland's Jurassic wealth

Deep under the seas around Scotland, the buried Jurassic sea-floor muds were rich in organic matter such as dead marine plankton. Under heat and pressure, over millions of years, the organic matter was converted to crude oil and natural gas.

Scotland's resources of oil and gas are truly precious. They contain irreplaceable energy which microscopic sea plants captured from sunlight when dinosaurs ruled Scotland.

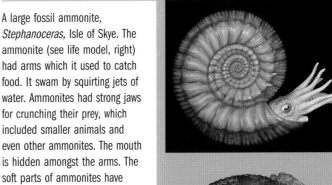

Scotland moves further north of the Equator.

A large fossil ammonite, *Stephanoceras,* Isle of Skye. The ammonite (see life model, right) had arms which it used to catch food. It swam by squirting jets of water. Ammonites had strong jaws for crunching their prey, which included smaller animals and even other ammonites. The mouth is hidden amongst the arms. The soft parts of ammonites have never been found in fossils and so they have been reconstructed by comparing them with living relatives like the pearly nautilus. (Model: J Hunt; photo: S Stevenson/NMS; fossil: Department of Geology, National Museum of Wales)

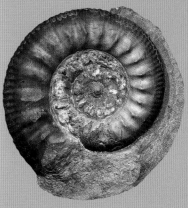

Skye in Jurassic times. This painting by John Sibbick shows life in the warm shallow seas around the fringes of Scotland. Ichthyosaurs (dolphin-like marine reptiles), ammonites, and squid-like belemnites can be seen. Sharks are scavenging the carcass of a dead dinosaur in the background, perhaps washed down river to the sea, and shellfish are living on the sea floor. (J Sibbick)

39

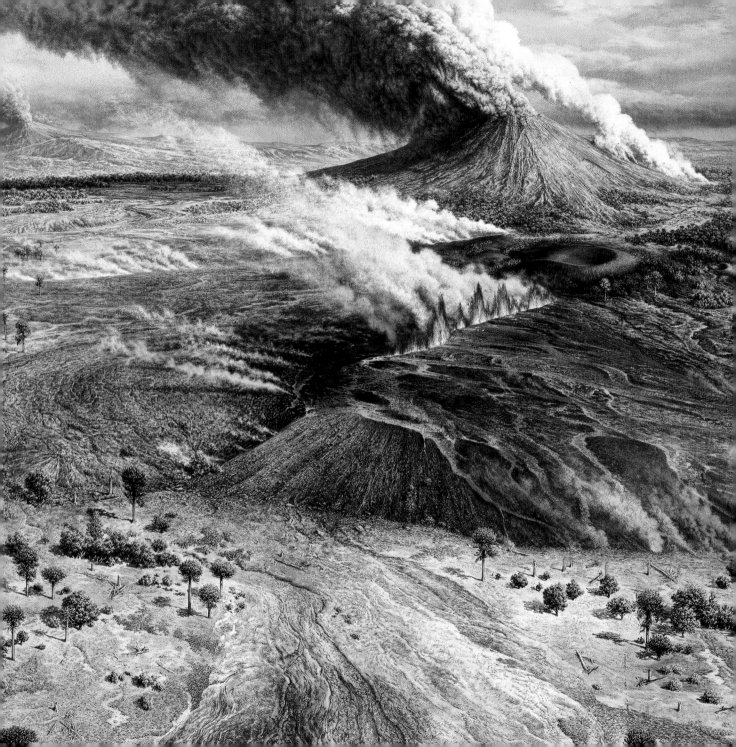

THE HIGH LAVA PLATEAUS

ABOUT 60 MILLION YEARS AGO

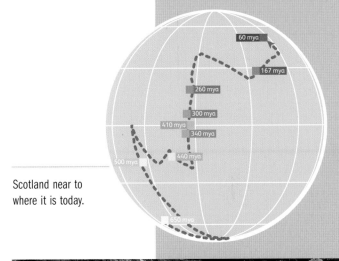

Scotland near to where it is today.

Early in the Paleogene Period the Atlantic Ocean was widening, to separate Scotland still further from Greenland and North America. The same processes that caused this widening stretched western Scotland. Great faults opened up and lava poured out repeatedly from these fissures to cover western Scotland. These lava flows built up into high plateaus, maybe as much as 5000 metres high (by comparison Ben Nevis is only 1344 metres high).

When the lava cooled in the fissures it formed dykes and sills. A dyke was formed when lava forced its way upwards through layers of rock; it often tends to stand out when the softer rock around it has eroded away – hence the name, taken from the Scots word for a field wall. A sill (often giving a step or shelf in the landscape) was formed when the molten lava followed layers in the rock.

The destruction of the lava plateaus

The volcanic uplands have been almost destroyed by 60 million years of erosion, which has even exposed the huge reservoirs of once-molten rock that fed the volcanoes, dykes and sills. The Cuillin Hills of Skye are carved out of one such reservoir. Other such remnants are found on the islands of Rùm, Mull, Arran and St Kilda, and on the mainland at Ardnamurchan.

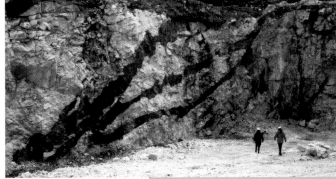

Several dykes of black basalt in the white marble of Torrin Quarry, Isle of Skye. Molten lava forced its way up through faults in the marble before cooling. (S Stevenson/NMS)

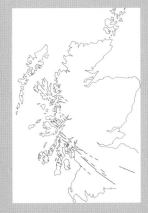

What would have been seen near Skye? A high volcanic plateau of old lava flows forested with monkey-puzzle trees; red-hot lava fountains from the latest fissure; in the distance a huge volcano whose eroded remains today form Ben More, Isle of Mull. (Painting: J Sibbick)

Right: Map showing the main dykes of this period in Scotland.

41

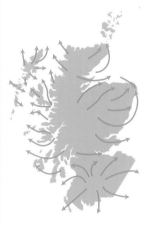

0 mya
60 mya
167 mya
260 mya
300 mya
410 mya
340 mya
440 mya
500 mya
650 mya

Scotland reaches its present position.

Lairig Ghru, Cairngorms, a valley deepened by a glacier. (BGS)

Map showing the flow of the glaciers over Scotland.

THE ICE AGES

The last 1.8 million years, most of which comprise the Pleistocene Epoch, are commonly called the Ice Ages. By then Scotland was located where it is today. Sometimes, like today, its climate was temperate, but more often its climate was Arctic.

Ice covered Scotland during the coldest periods, the last of which was about 30,000 to 15,000 years ago. Snow did not melt annually, but built up year after year, compressed into ice under its own weight. In places it became hundreds of metres thick, almost as high as Ben Nevis. Scotland looked like central Greenland does today, an icy desert with the odd mountain-top poking through.

This natural deep-freeze did not preserve Scotland in good condition. The ice destroyed the old landscape and created the scenery you see today. When ice becomes tens and hundreds of metres deep, it flows under its own weight, maybe a few metres a day, to give enormous slow-moving rivers of ice called glaciers. Glaciers fanned outwards from the Highlands and the Southern Uplands. They were like icy sandpaper, full of stones and grit which they had broken off exposed rocks. When they flowed over the ground, their grit-laden undersides scraped away the soil, then dug deep into the rock below. In hilly areas the glaciers gouged out high corries and flowed down valleys, deepening them into u-shaped glens. Low land was scraped clean.

Littering Scotland

The glaciers ground and scraped up the rocks of Scotland, then moved and dumped them elsewhere, in what are called glacial deposits. The resulting layer of ground-up rock, mixed with assorted pebbles and boulders, called boulder clay or till, covers much of Scotland. The ice also moved rocks ranging from small pebbles to huge boulders, often for tens, sometimes hundreds, of kilometres. These transported rocks are called erratics.

When the ice melted

When the climate warmed, the ice started to melt more and more each summer, causing the ice-sheets to shrink. Swollen rivers of melt-water washed the rock debris free from the ice and left thick deposits of sand and gravel over much of Scotland. This has produced a variety of landscape forms from sinuous melt-water channels to snaking mounds (kames and eskers) and hummocky mounds (drumlins).

1 A glacier smoothed, scratched and gouged this hard volcanic rock (centre of picture) near Ratho, Midlothian. (S Miller/NMS)

2 A large boulder at Gart, near Callander, Perthshire, left by a glacier. (BGS)

3 Melt-waters from glaciers in the Southern Uplands scoured out this channel near Dunbar in East Lothian. Today, without glacial melt-water to feed it, what is now the Spott Burn flows through a valley much too big for it. (BGS)

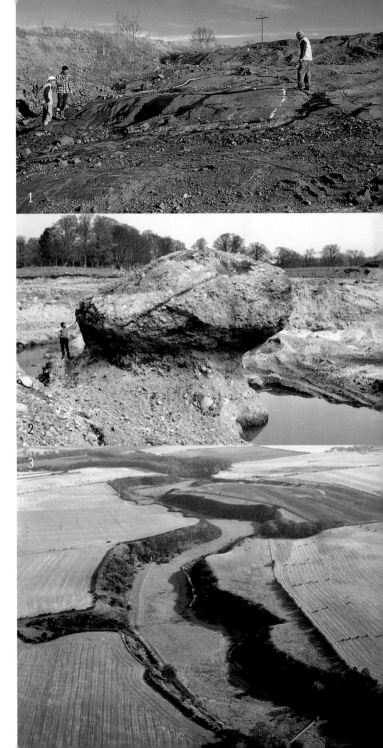

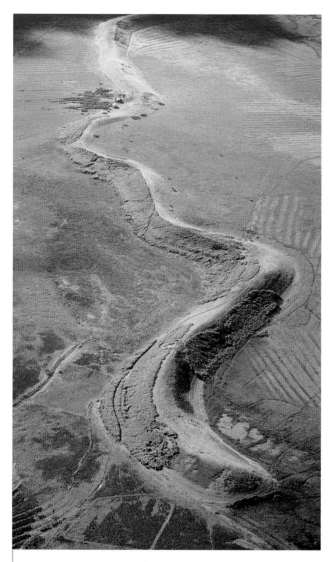

This mysteriously snaking mound of
sand at Bedshiel, Berwickshire, was
left by a glacier. Perhaps the sand
was deposited by a river flowing
through a tunnel in the ice.
(P & A Macdonald)

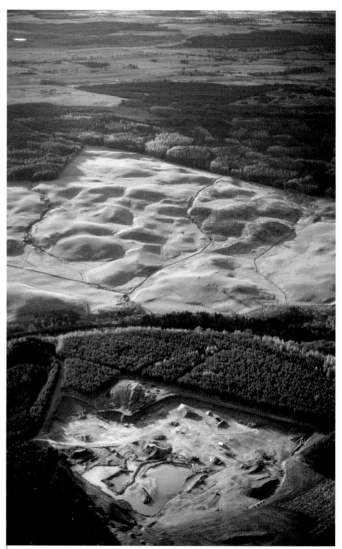

Quarrying sand and gravel from a
hummocky deposit. Gravel pit
south of Callander, Perthshire.
(P & A Macdonald)

CHANGES OF CLIMATE

The Ice Ages were not always cold. The climate varied tremendously. Long icy periods were broken up by warmer periods when the climate was much the same as it is in Scotland today. But 30,000 years ago Scotland was in the later part of a long cold period called the Devensian Stadial. For most of the Devensian, Scotland was covered by ice, over which the occasional polar bear roamed.

Sometimes the climate was a little less cold. Animals such as woolly mammoth, woolly rhinoceros and reindeer lived on the almost permanently frozen ground to the south of the ice. They ate grasses and low-growing Arctic plants such as dwarf willows.

Just over 15,000 years ago, the climate improved markedly, melting most of the Scottish icecap. It became almost as warm as today. But 2000 years later the cold conditions returned during a period called the Loch Lomond Stadial. From the remnants of the Scottish ice-cap, the ice readvanced to cover much of the Western Highlands, and small glaciers grew again in high valleys elsewhere.

About 11,750 years ago the climate warmed again and the ice melted at the end of the Pleistocene. This was the start of the comparatively warm period in which we live today, called the Holocene. The fossils of this period are of warm climate animals like Giant Deer.

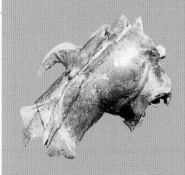

The first polar bear, *Ursus maritimus*, fossil found in Scotland. This incomplete skull from Assynt, Sutherland, is about 22,000 years old, as we know from radiocarbon dating. (K Smith/NMS)

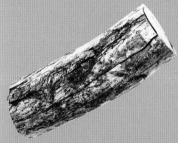

Part of the tusk of a woolly mammoth, *Mammuthus primigenius*, from Clifton Hall, near Edinburgh. (N McLean/NMS)

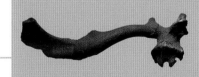

Part of the skull and (left) antler, seen from the rear and above, of a giant deer, *Megaloceros giganteus*, from the bed of the River Cree, Wigtownshire. This kind of deer, also called the Irish Elk, lived in temperate climates much like today's. The stags had huge antlers, up to 3.5 metres across. (I Larner/NMS)

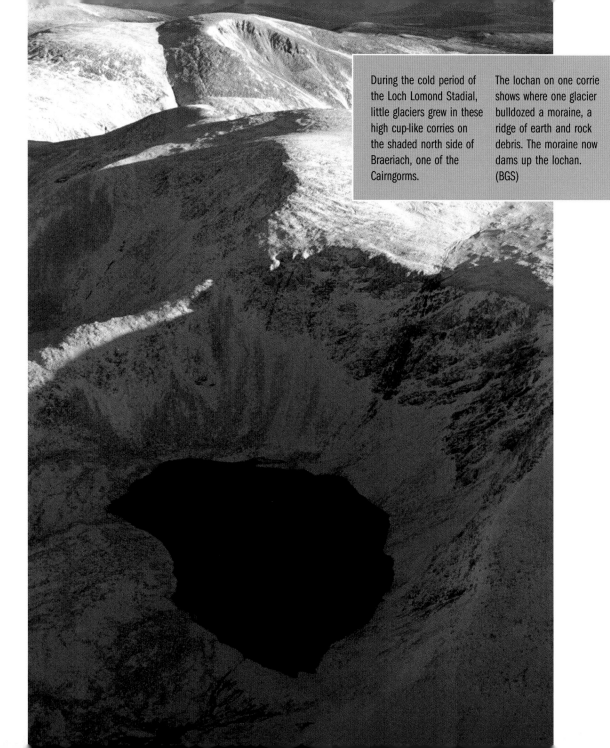

During the cold period of the Loch Lomond Stadial, little glaciers grew in these high cup-like corries on the shaded north side of Braeriach, one of the Cairngorms.

The lochan on one corrie shows where one glacier bulldozed a moraine, a ridge of earth and rock debris. The moraine now dams up the lochan. (BGS)

ANCIENT SEASIDES

Scotland's coasts changed dramatically during the Ice Ages. In cold periods large amounts of water froze on land, forming icecaps. This locked up water which would otherwise have topped up the oceans. So the sea level fell. But when the climate warmed the ice melted and the sea level rose.

During the Late Devensian the sea level fell so low that parts of the North Sea and English Channel were dry land and Britain was connected to the rest of Europe.

When the climate warmed, the ice finally melted during the early part of the Holocene Epoch, which began 11,750 years ago. The sea came back and flooded the low land, cutting Britain off from Europe. However, Scotland had sunk under the weight of the ice, by as much as 15 metres around Rannoch Moor where the ice was thickest. When the ice melted and the sea level rose, the sea flooded land near the coasts. But the weight of the ice was released and the land sprang back very slowly over thousands of years.

As sea levels changed, the sea eroded new shorelines. You can often see these ancient beaches around Scotland, up to c.30 metres above present sea level. Sometimes there are several raised beaches one on top of another like steps in a staircase. Other ancient beaches are under the sea today.

If Scotland was covered by ice, how did animals and plants get back again when the ice melted? The answer is: because Britain wasn't an island. The map shows the situation about 16,000 years ago.

The weight of the icecap made Scotland sag in the middle. When the ice melted and the weight was released, the land started to spring back very slowly. Over thousands of years, some areas of Scotland's coasts partially re-emerged from the sea.

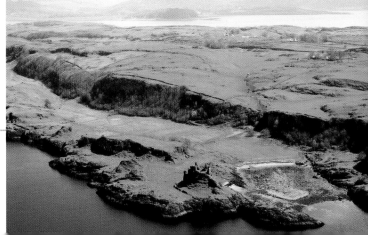

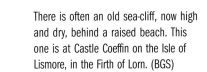

There is often an old sea-cliff, now high and dry, behind a raised beach. This one is at Castle Coeffin on the Isle of Lismore, in the Firth of Lorn. (BGS)

PART 2
SCOTLAND'S WILDLIFE

Andrew C Kitchener

INTRODUCTION TO PART 2

Scotland is renowned today for its rich and varied wildlife, including iconic species like the golden eagle, the wildcat, Scottish primrose and Scots pine. However, what we see today is a result of mostly recent changes in climate and habitats, brought about partly by natural cycles, but also increasingly by human activities. In this part of the book we look at the evidence for Scotland's changing wildlife, and determine how important it is to look after it for our enjoyment and economic benefit both today and for future generations.

White water lilies, Uath Lochan, Inshriach, Glenfeshie, Strathspey. (NPL)

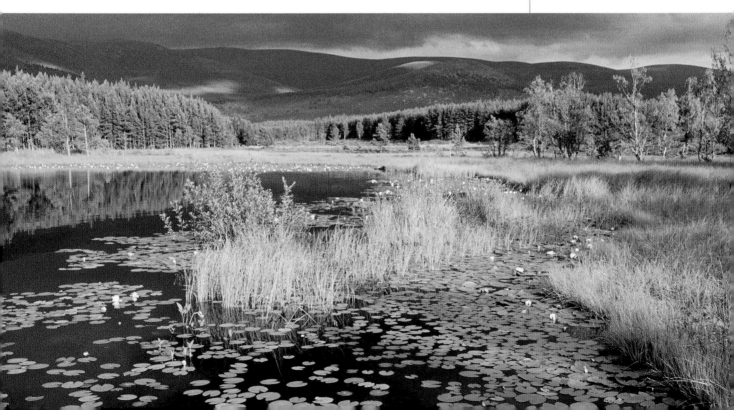

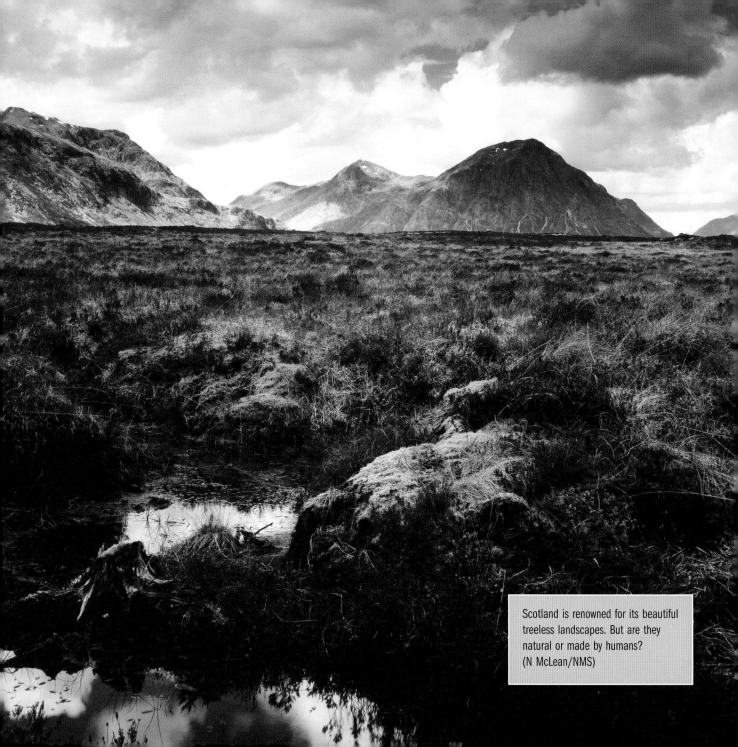

Scotland is renowned for its beautiful treeless landscapes. But are they natural or made by humans? (N McLean/NMS)

SCOTLAND TODAY

A NATURAL WILDERNESS?

Many people think of Scotland as a natural wilderness, but much of what we see today has been created by human activities over the last 6000 years.

At the end of the last Ice Age (11,750 years ago) the land was freed from the ice sheet that had scraped it bare, and it began to be colonised by plants and animals. As the climate continued to warm up, the wildlife of Scotland changed; and it has continued to change ever since.

To discover what Scotland might have looked like today if people had not changed the land to suit their needs, we need to equip ourselves with useful tools for investigating the evidence for Scotland's changing wildlife.

Investigating the past

Since the end of the last Ice Age the wildlife of Scotland has been continually changing. This has been caused mainly by warming of the climate and by human activities such as farming. However, much of this change occurred before historical records began.

So how can we investigate the past history of Scotland's wildlife? There are four main complementary lines of evidence:

- Relict species
- Fossils
- Radiocarbon dating
- Pollen analysis

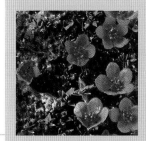

RELICT SPECIES
Purple saxifrage, *Saxifraga oppositifolia*, is a relict species that shows Scotland was once much colder than today.
(N McLean/NMS)

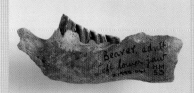

FOSSILS
A fossil jawbone of a Eurasian beaver, *Castor fiber*, shows that this species once lived in Scotland. (N McLean/NMS)

RADIOCARBON DATING
Radiocarbon dating this wild horse, *Equus ferus*, leg bone shows us when this animal lived in Scotland. (N McLean/NMS)

POLLEN ANALYSIS
Analysing pollen grains in peat-bogs, etc., shows how the vegetation of Scotland has changed over time.
(M Collinson)

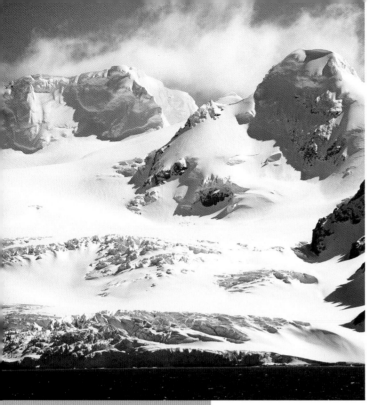

RELICT SPECIES
ICE AGE SURVIVORS

Some Arctic species of animals and plants still survive in Scotland today. They once had a wider distribution in Europe because the climate was much cooler during the last Ice Age. As the climate warmed up, many species that were adapted to cold Arctic climates became extinct in Scotland. However, some were left stranded in patches of suitable habitat (e.g. on mountains or in deep seas) that still exist today. These Ice Age survivors are called 'relict species' and there are many examples in Scotland today.

Molluscs

There are several Arctic species of mollusc (shellfish) surviving in the deeper waters of Scotland's seas where the water is cool enough ($c.4°$C all year round). For example the Arctic clam, *Panomya arctica*, is found in mud and muddy or sandy gravel from Iceland and Norway to the British Isles. In Scotland it has only been recorded off the west coast of the mainland, in waters too deep to be warmed by the North Atlantic Drift (Gulf Stream).

Insects

There are many relict insects, which survive mainly in cold mountainous areas of Scotland. Several species of beetle are known to be relict species in Scotland.

For example the ground beetle, *Nebria nivalis*, was first

Scotland was covered by a thick layer of ice during most of the last Ice Age. (NPL)

The Arctic clam, *Panomya arctica*, is a relict mollusc. (N McLean/NMS)

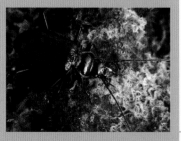

The ground beetle, *Nebria nivalis*, is a relict beetle species which is often found near permanent snow. (Roy Anderson, www.habitas.org.uk/groundbeetles)

recorded on mountain tops in Britain in 1950. Before then it had only been recorded in the north of Scandinavia and Russia. Although it had been overlooked in the past, this beetle is fairly widespread in Scotland, north-west England and Wales.

Mammals

Scotland's only relict mammal species is the mountain hare, *Lepus timidus*, which once had a wide distribution throughout Europe during the last Ice Age. It evolved into a unique geographical race (*Lepus timidus scoticus*) in the Highlands of Scotland when Britain was cut off from Europe more than 9500 years ago. Other races evolved in Ireland (*L. t. hibernicus*) and the Alps (*L. t. varronis*).

Fish

The ancestors of today's loch-bound Arctic charr, *Salvelinus alpinus*, and coregonid fish (e.g. powan, *Coregonus lavaretus*, and vendace, *Coregonus albulus*) used to breed like salmon, *Salmo salar*, and sea trout, *Salmo trutta*. The adults migrated from the sea to spawn in freshwater rivers and lochs, where the young hatched and developed before returning to the sea.

As a result of changing sea levels and the effects of glaciation during the last Ice Age, populations of these fishes became isolated in lochs where they have evolved into distinct forms. In this way Scottish populations have become isolated and fragmented, in contrast to populations elsewhere in northern Europe which are still able to follow the ancestral migration to and from the sea.

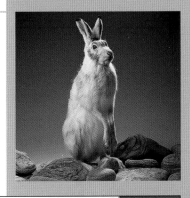

The mountain hare, *Lepus timidus*, is Scotland's only relict mammal. It has been introduced to the Borders and many islands in Scotland. (N McLean/NMS)

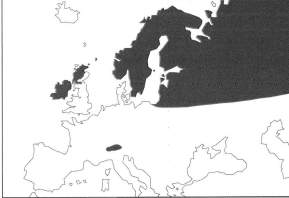

Distribution map of the mountain hare in Scotland and Europe today.

In Scotland the powan, *Coregonus lavaretus,* has only been recorded from Loch Lomond and Loch Eck. Elsewhere in Britain it occurs in the Lake District and North Wales. (N McLean/NMS)

53

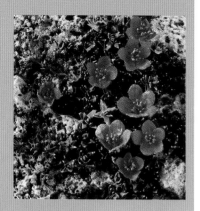

Distribution map of the purple saxifrage, *Saxifraga oppositifolia* (left), in Scotland and Europe today. (N McLean/NMS)

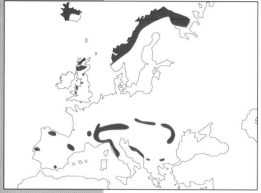

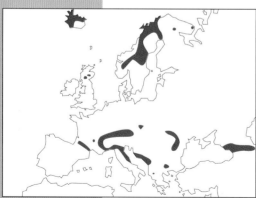

Distribution map of the Alpine gentian, *Gentiana nivalis* (right), in Scotland and Europe today. (N McLean/NMS)

Arctic plants

Several Arctic plant species have survived in Scotland in suitable habitats in the uplands, such as on the Cairngorm plateau. Arctic plants grow to only a short height, as an adaptation to avoid freezing and very dry winds.

In Scotland the Alpine gentian, *Gentiana nivalis*, is restricted to the mountain ranges of Ben Lawers, Perthshire, and Caenlochan in Angus; however, in northern Scandinavia it is also found at lower elevations, because of the cooler climate there.

The purple saxifrage, *Saxifraga oppositifolia*, is one of the earliest mountain plants to flower in Scotland, and it grows also on the north coast of Greenland, where almost no other flowering plants survive. It is well adapted to growing in cold conditions either as a cushion, which retains heat, or as a trailing mat which takes advantage of the sun's heat reflected from rocks. Its bowl-shaped flowers trap the sun's heat to speed up the development of seeds.

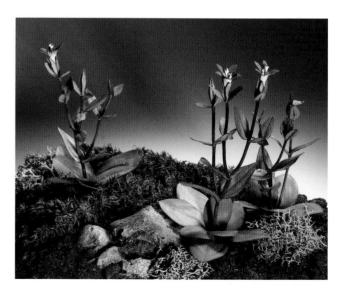

FOSSILS

EVIDENCE FOR THE EXTINCT

Some species became extinct in Scotland owing to climate change or human activities. We know that they did exist from the preserved remains of bones, seeds, pollen and wood found in peat, clay, gravel and caves. When animals or plants die, their hard parts (e.g. bones, seeds, etc.) often become buried and some are preserved as fossils. Unfortunately conditions in Scotland are very poor for the preservation of fossil bone for the following reasons:

- Much of Scotland has acid soils that dissolve bones.

- The grinding action of glaciers completely destroyed many fossils from before and during the Ice Age.

- Scotland has few limestone caves, which provide particularly good conditions for preserving bone.

Therefore fossil bones are not commonly found in Scotland. The best site found so far is the Creag nan Uamh caves in the limestone area of Assynt, Sutherland, where several thousand bone fragments have been recovered.

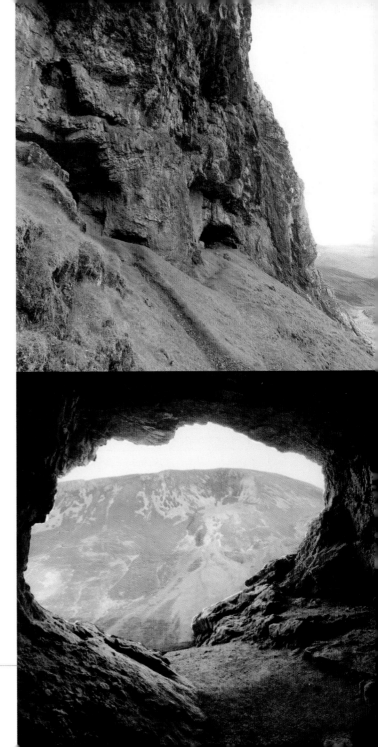

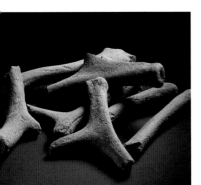

Above, right: The Creag nan Uamh caves, Assynt, Sutherland, comprise one of the best sites for preservation of fossil bone in Scotland. Right: view from inside the Reindeer Cave. (N McLean/NMS)

Left: Reindeer antler fragments from the Reindeer Cave. (N McLean/NMS)

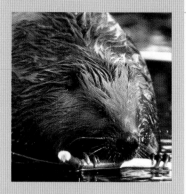

Left: Fossil bones show that beavers were once found in various parts of Scotland. (W Lynch/Parks Canada)

Far right: A birch log found in West Morriston Bog, Berwickshire, Scottish Borders, showing tooth marks made by beavers. (N McLean/NMS)

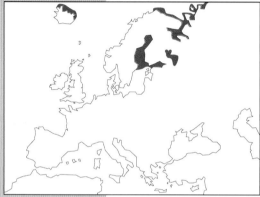

Above: Distribution map of the ringed seal, *Phoca hispida*, in Europe today.

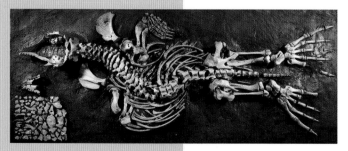

Ringed seal fossils such as this skeleton have been found buried in clay at several sites on the coast of eastern Scotland. (NMS)

Plants

Plant fossils may survive as pollen grains, seeds, leaves, stems, roots and petals in peat and lake muds.

Birch (*Betula* sp.) logs (such as the example below) were excavated from West Morriston Bog, Berwickshire. They have tooth marks made by beavers at each end, which indicate that beavers once lived in Berwickshire. Fossil bones also show that beavers were once found in several other parts of Scotland.

Mammals

Today the ringed seal, *Phoca hispida*, is found in the Arctic, although it occurs also as a relict in the Baltic Sea and two Finnish lakes, as well as occasionally as a vagrant in Shetland and Orkney. Fossils, such as the skeleton (below, left) from Stratheden in Fife, have been found buried in clay at several sites on the coast of eastern Scotland. The former presence of this species in Scotland shows that the climate was once similar to that of the Arctic today.

Molluscs

After the last Ice Age the sea warmed up and many Arctic molluscs became extinct in and around Scotland.

The Arctic clam, *Portlandia arctica*, was found in marine deposits at West Benderloch, Argyllshire, and has been radiocarbon dated to about 12,000 years old. Today *Portlandia arctica* is extinct in Scottish seas, but is widely distributed in northern Arctic seas at depths of up to 340 metres in both the Atlantic and Pacific Oceans.

FOSSILS

RECONSTRUCTING PAST HABITATS

Fossils of living species can be used to reconstruct the habitats of the past. First the fossils are identified by comparing them with modern specimens. Then the combination of species found in an area with a known geological age (see radiocarbon dating on page 59) suggests the probable habitat and climate on the basis of where these species survive today.

Even the smallest fossils are important, although their fragility means they are often rare and their size means they are often overlooked. Very small bones and other fragments tell us what small animals lived in Scotland at the end of the last Ice Age, and seeds and pollen indicate the plant cover.

The fossil animals and plants that date from the end of the last Ice Age and soon after, tell us that Scotland was covered mainly by tundra. Tundra is the open treeless habitat found in Arctic regions today, where the growing season for plants lasts only a few months each year and only a thin surface layer of the permafrost (permanently frozen ground) thaws in summer.

Evidence of tundra rodents

Three species of rodents (gnawing mammals) from the tundra of northern Europe and Asia have been found in caves and lake deposits in Scotland, including the collared lemming, *Dicrostonyx torquatus*, the northern vole, *Microtus oeconomus*, and the tundra vole, *Microtus gregalis*.

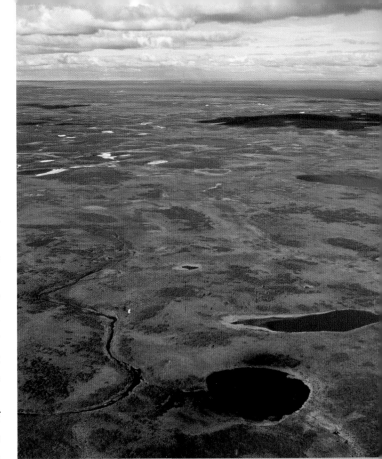

Above: Scotland once looked similar to the open treeless tundra that can now be found in the Russian Arctic. (NPL)

The collared lemming (right), has a wide distribution in the tundra of northern Russia. The mandible (lower jaw) (right, above) was found in the Creag nan Uamh caves, Sutherland. Elsewhere in Scotland, fossil collared lemmings have only been recorded from Corstorphine, Edinburgh. (N McLean/NMS; jaw: NMS)

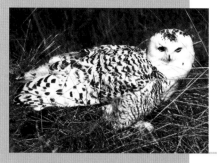

Evidence from rodent fossils suggests that the snowy owl once lived in Scotland. (T W Hall/Parks Canada)

The polar campion, *Silene furcata* (below), is an Arctic species known in Scotland from just one seed, found at Straloch near Pitlochry, Perthshire. It dates from the end of the last Ice Age. (Photo: NMS; seed: G Steven and T N Tait, University of Glasgow)

Arctic poppy seeds have been found only in three localities in Scotland. (Photo: W Lynch/ Parks Canada)

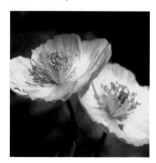

The elytra (wing cases) of the Arctic ground beetles, *Diacheila arctica* (far left) and *Boreaphilus henningianus* (left), have different characteristic surface textures. (NMS)

Evidence of snowy owls

Damage to the skulls of tundra rodents from the Creag nan Uamh caves, Sutherland, show they had probably been killed by snowy owls, *Bubo scandiacus*, although there is no direct fossil evidence of snowy owls from Scotland.

Evidence of tundra plants

Fossil seeds and parts of whole plants are found preserved in lake muds and peats. Some of these show us the tundra plants that once lived in Scotland.

The Arctic poppy, *Papaver radicatum*, survives only in the Arctic tundra in northern Europe and Asia, and as a relict in the mountains of southern Scandinavia.

Evidence of tundra beetles

Beetles have their front wings modified to form hard wing cases called elytra, which are often preserved with other hard structures in peats or silts. Some beetle species can be identified from the characteristic shape and texture of their elytra. Preserved elytra and other hard structures show that many Arctic species of beetle once lived in Scotland.

The carnivorous Arctic ground beetle, *Diacheila arctica*, is found today mostly in the tundra of northern Europe and Asia, but it extends also into boreal (northern) forests. It has been found as an Ice Age fossil at many sites in Britain, including four in southern Scotland. Those found at Redkirk Point near Gretna Green, Dumfries and Galloway, are about 11,000 years old.

RADIOCARBON DATING

DATING THE PAST

Relict species, fossils and pollen grains indicate the species of plants and animals that once lived in Scotland and what the climates and habitats were once like. However, they cannot tell us when these species existed, or when the environment changed.

We can calculate the ages of fossils by measuring the amount of radioactive carbon left in them.

How does radiocarbon dating work?

- From the moment it is first formed in the atmosphere, radiocarbon is prone to breaking down, decaying at the constant rate of half every 5730 years to form nitrogen gases and a radioactive beta particle.
- At death no more radiocarbon is added to bone or wood, which may be preserved as fossils, and over time the amount of radiocarbon declines.
- By measuring the proportion of radiocarbon in a fossil it is possible to calculate how long the animal or plant has been dead.
- A slight adjustment is made to radiocarbon dates to convert them to calendar dates, because errors of about 1800 years have been found for specimens that are 10,000 radiocarbon years old. Errors occur because the rate of formation of radiocarbon in the upper atmosphere may not have been constant in the past. Also, as radiocarbon in the seas is not in equilibrium with that in the atmosphere, marine animals appear much younger.

What is radiocarbon?

Radiocarbon is radioactive carbon. It is produced in the upper atmosphere through bombardment of nitrogen gas by cosmic rays.

1. The radiocarbon reacts immediately with the oxygen in the air to form carbon dioxide.

2. As a result, a constant proportion of the carbon in the atmosphere is radioactive (about one in a million molecules).

3. Carbon dioxide is taken up by plants through photosynthesis (a process using sunlight as an energy source), to be converted to carbohydrates, proteins and fats.

4. Therefore the same constant proportion of the carbon found in plants is also radiocarbon and this is passed on to animals via the food chain in the same amounts.

1 Elk, *Alces alces*, antlers from Whitrig Bog, Berwickshire.

Radiocarbon activity level 37.9% = 7780 radiocarbon years (8540 calendar years)

2 Fragment of Eurasian beaver's lower jaw, *Castor fiber*, found in a cave at Cleave's Cover, Dalry, Ayrshire.

Radiocarbon activity level 70.7% = 2750 radiocarbon years (3000 calendar years)

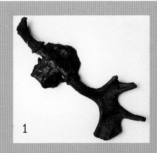

3 Fragment of wild horse's leg bone, *Equus ferus*, found in a rocky crevice at Green Craig, Pentland Hills, near Edinburgh.

Radiocarbon activity level 28.2% = 10,230 radiocarbon years (12,000 calendar years)

59

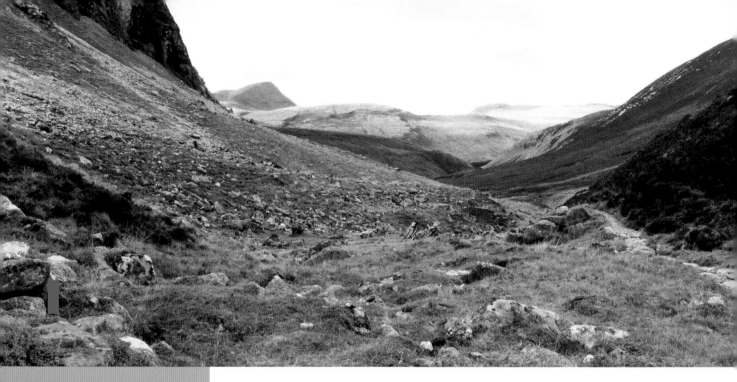

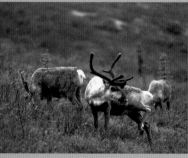

The Allt nan Uamh valley, Assynt, was a traditional reindeer calving ground for almost 50,000 years. (N McLean/NMS)

Left: Reindeer (caribou) on calving ground. (W Lynch/Parks Canada)

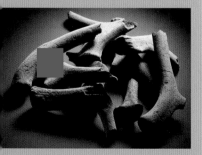
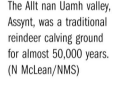

Hundreds of reindeer antler fragments from Creag nan Uamh are mostly from females and their calves. (N McLean/NMS)

The reindeer of Assynt

Hundreds of fragments of reindeer antlers have been found in the Creag nan Uamh caves near Inchnadamph, Assynt, Sutherland. These have been analysed and radiocarbon dated to give information about the lives of the reindeer that lived there.

Radiocarbon dating shows that female reindeer and their young were living there during three periods: 47-43,000 radiocarbon years ago, 33-26,000, and 9700 calendar years ago.

This tells us that the Assynt area was used by reindeer as a traditional calving ground over the last 50,000 years, except during the coldest parts of the last Ice Age when Scotland was almost completely covered in ice. The terrain of this area was similar to that of traditional calving grounds of reindeer (caribou) in Alaska today.

POLLEN ANALYSIS

Flowering plants fertilise each other with pollen to produce seeds. Many species depend on wind to carry their pollen to other plants and must produce huge quantities of pollen grains each year to ensure successful fertilisation.

Much of this pollen rain falls to the ground. When it falls over peatlands and lake muds, rotting often does not occur as there is not enough oxygen in these substrates. The peat-bog or lake muds preserve the pollen, and over thousands of years a record is built up of pollen that has fallen in that area.

Most plant species or groups of species produce pollen grains with their own distinctive shapes and surface features.

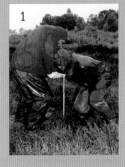

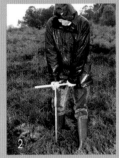

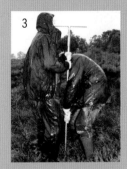

A record of the past: a peat-core

Peat develops gradually over time from dead plant material, so that the oldest layers are found furthest below the surface of the peat-bog. By analysing the proportion of different types of pollen at different levels in the peat, and radiocarbon dating each layer, it is possible to reconstruct the past plant cover in a particular area and investigate changes over time.

A peat-core is extracted from a bog by

1 pushing the peat-corer in
2 twisting the corer
3 pulling the corer out
4 and examining the peat-core

(Photos: N McLean/NMS)

1 Heather, *Calluna vulgaris* (L Taylor/ NMS), with pollen. (M Collinson)

2 Hazel, *Corylus avellana* (N McLean/ NMS), with pollen. (M Collinson)

3 Alder, *Alnus glutinosa* (N McLean/ NMS), with pollen. (M Collinson)

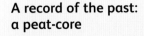

POLLEN ANALYSIS

RECONSTRUCTING PAST HABITATS

The species of trees that dominated the natural woodland of the Central Lowlands of Scotland were oak (left), hazel, elm and alder. These species between them produced 94% of the pollen that was preserved. This is a sessile oak, *Quercus petraea*. (N McLean/NMS)

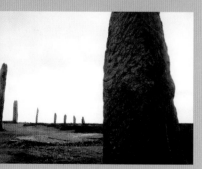

Birch woodland was replaced by Scots pine as the climate warmed up. This woodland (left) is in the Cairngorms, near Braemar. (L Taylor/NMS)

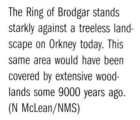

The Ring of Brodgar stands starkly against a treeless landscape on Orkney today. This same area would have been covered by extensive woodlands some 9000 years ago. (N McLean/NMS)

Pollen analysis tells us about the changes in plant life in a particular area. These can often be linked to known changes in climate or to the activities of people. The history of the plant life may vary considerably throughout Scotland.

Central Lowlands

Oak, hazel, elm and alder dominated the natural woodland of the Central Lowlands of Scotland, producing 94 per cent of the pollen that was preserved. Today only 15 per cent of the Central Lowlands is covered by trees, but only one per cent is original wild wood, which has been modified by human activities. By 2000 years ago most of the trees had been removed.

Cairngorms

Ten thousand years ago the Cairngorms were covered by birch woodland which was replaced by Scots pine as the climate warmed up. There was a sharp decline in trees over the last 2000 years.

Orkney

The Orkney Islands are virtually treeless today, but 9000 years ago there was an extensive woodland of birch, willow and hazel. Trees had largely been cut down before 2500-3000 years ago.

HISTORY OF THE FORESTS

11,750 YEARS AGO

Holocene Period

- Most of the ice has melted, but the climate is still cold.
- Scotland is still attached to mainland Europe by a land bridge.
- The land is dominated by a treeless tundra of grasses, sedges and other Arctic plants.
- Arctic mammals and birds thrive on the tundra.

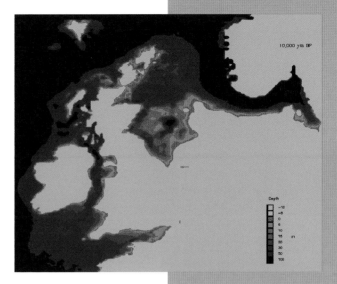

Scotland once looked like the frozen tundra on Talan Island, East Russia. (NPL)

Above: Map of the early Holocene Period, 11,750 years ago. (University of Durham)

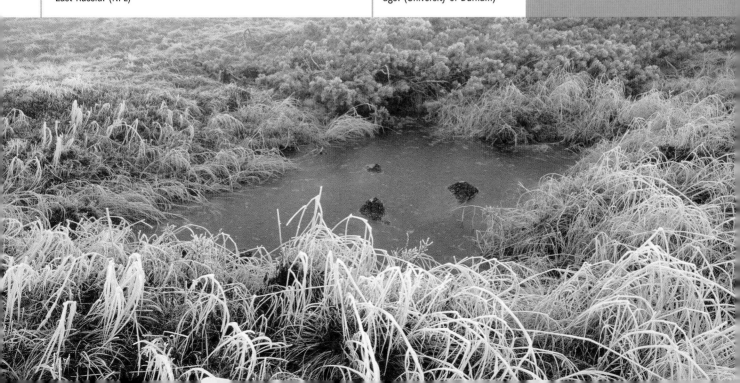

Timeline of tree colonisation in Scotland	
before 11,750 years ago	Juniper, *Juniperus communis*
9600–10,000 years ago	Birch, *Betula* spp.
9000–9500 years ago	Hazel, *Corylus avellana*
8000–8500 years ago	Wych elm, *Ulmus glabra*
8000–8500 years ago	Oak, *Quercus* spp.
7000–7500 years ago	Scots pine, *Pinus sylvestris*
6500 years ago	Alder, *Alnus glutinosa*

HISTORY OF THE FORESTS

FROM 11,750 TO 6000 YEARS AGO

As the climate warmed up and the ice melted, so Scotland began to be colonised by plants and animals that had been living at the edge of the ice sheet.

A treeless tundra of Arctic plants developed at first, but as the climate warmed trees soon began to dominate the land. A succession of different species of tree colonised Scotland at different times, according to temperature, the development of soils, and the rate of dispersal of seeds. The main species of trees are listed in the table on this page.

By 6000 years ago no more trees colonised naturally and the kinds of tree in the forests had stabilised. These final assemblages of trees and other plants are called climaxes.

Below: Tundra, 11,750 years ago.
(Diorama photos: N McLean/NMS)

Left: Icecap of Loch Lomond Readvance (or Stadial), *c.*11,500-10,500 radiocarbon years ago.

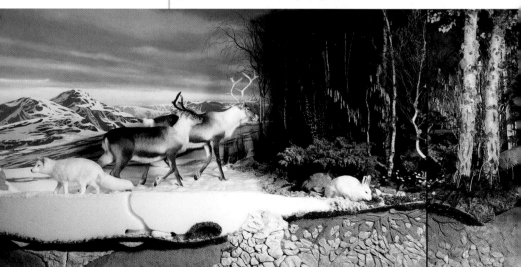

Distribution of the main types of tree

Although the woodland varied locally owing to differences in terrain, soils, climate and height above sea level, there were four main kinds:

- Scots pine and birch in the Highlands
- Birch, hazel and oak in the North-East
- Oak, hazel and wych elm in the Lowlands
- Birch and hazel in the north, and the Northern and Western Isles

The 'History of the Forests' diorama

The diorama below shows how the Arctic tundra at the end of the last Ice Age was replaced by oak forests in the Lowlands and pine forests in the Highlands. It is based on evidence from relict species, subfossils, pollen analysis and radiocarbon dating. Can you see which animals are extinct in Scotland today?

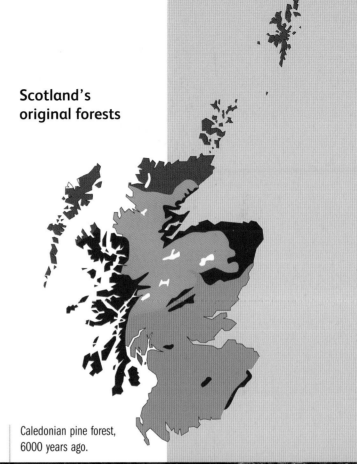

Scotland's original forests

Lowland oak forest, 6000 years ago.

Caledonian pine forest, 6000 years ago.

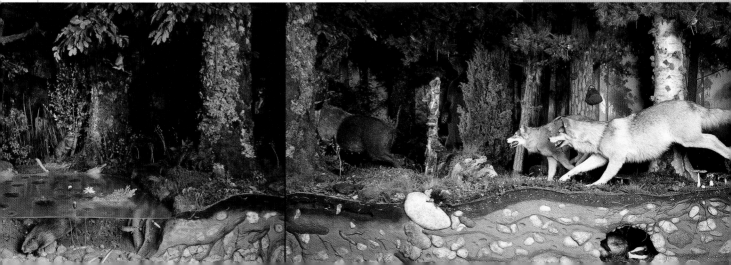

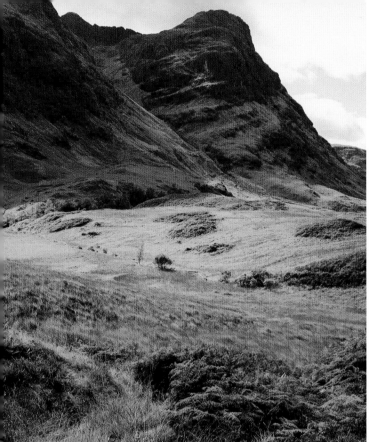

HISTORY OF THE FORESTS
FORMER TUNDRA AND FOREST LIFE

Scotland's extinct species

Most of the evidence for changes in the animal life of Scotland comes from fossils of its larger species. In the poor conditions available for bone preservation in Scotland, the bones of large species are more likely to survive than those of smaller species. In the following pages some of the rarest and finest known fossils of species now extinct in Scotland are featured.

Tundra mammals

Most of Scotland's Arctic plants and animals became extinct soon after the end of the last Ice Age. As the climate warmed up, the specialised tundra plants no longer had an advantage and were displaced by species better adapted to the warmer climate. Animals favoured by cold conditions, as well as those dependent on the tundra plants, suffered a similar fate.

Reindeer (*Rangifer tarandus*): The reindeer has been recorded in many localities in Scotland. Its fossils have been found under peat-bogs and in clay, gravel and limestone caves. A leg bone from the Creag nan Uamh caves, Sutherland, radiocarbon dated to 9700 years old, provides the most recent date for the survival of Scottish reindeer.

Arctic fox (*Vulpes lagopus*): Has been recorded only as jaw fragments from cubs from the Creag nan Uamh caves, Sutherland.

The dramatic scenery of Glencoe. (M Sumega/NMS)

This antler was cast (shed) by a male reindeer before it was preserved as a fossil. It was found at Crossgates, near Dunfermline, Fife, in 1995. (N McLean/NMS)

Arctic foxes have dense fur to protect them from cold Arctic weather. Climate changes after the last Ice Age caused their extinction in Scotland. (N McLean/NMS)

Forest mammals

Many large mammals were dependent on the forests, but they became extinct in Scotland owing to the loss of forest cover and to hunting by humans for fur, meat or sport. These species could survive in Scotland today, where suitable habitat still exists.

Elk (*Alces alces*): The elk is one of the largest living species of deer. Fossil remains have been found under peat-bogs or in river gravels in many parts of Scotland, but few specimens have survived excavation. Although there is no direct evidence for a more recent survival of the elk in Britain, the Gaelic animal names of *miol* or *lon* suggest it may have survived until beyond the ninth century AD in Scotland.

Brown bear (*Ursus arctos*): Has been found in only three localities in Scotland. The latest date of occurrence is based on a femur (thigh bone) found in the Creag nan Uamh caves, Sutherland, radiocarbon dated to about 2800 years old. A skull was found under a peat-bog at Shaws in Dumfriesshire and was radiocarbon dated to 8300 years old. Brown bears are said to have survived in Britain until the tenth century AD, but the evidence for this is poor. They may have become extinct by Roman times, about 2000 years ago.

Wolf (*Canis lupus*): Not as dependent on forests as other species, which may explain its probable survival in Scotland until the seventeenth, possibly the eighteenth century, by which time much of Scotland was cleared of forests. The last Scottish wolf was allegedly killed in

This elk antler is from the River Cree in Galloway and has been radiocarbon dated to 4370 years old. It is the most recent fossil evidence for the elk in Britain. (L Florence/NMS)

A skull of a brown bear, *Ursus arctos*, found in Dumfriesshire. (L Florence/NMS)

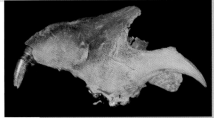

The brown bear survives only in small fragmented populations in Europe today, owing to hunting and habitat loss.

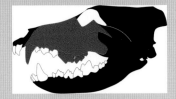

This piece of upper jaw of a wolf was found in clay at Portobello, Midlothian. The diagram below shows the position of the fossil in the skull. (Fossil photo: L Florence/NMS)

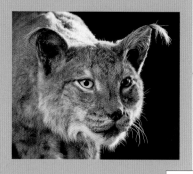

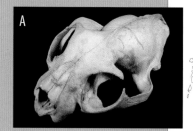

A

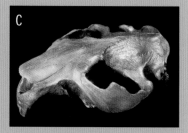

B

C

Left: Lynxes are medium-sized cats with distinctive tufted ears. They have large, furry paws adapted for walking on snow. (N McLean/NMS)

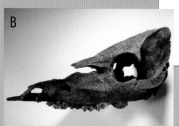

Fossil locality map:
1 Eurasian lynx (skull A)
2 Reindeer
3 Wolf
4 Wild pig (skull B)
5 Eurasian beaver (skull C)
6 Brown bear
7 Elk
(Photos: NMS)

1743, but there is some doubt about this record. Wolf remains are rare in Scotland.

Eurasian lynx (*Lynx lynx*): Still has a wide distribution in northern Europe and Asia. The skull (see skull A, below left) from the Creag nan Uamh caves, has recently been radiocarbon dated to 1800 years old. This suggests that the Eurasian lynx became extinct in Scotland because of human activities – habitat loss and hunting – rather than climate change as was once believed.

Wild pig (*Sus scrofa*): Often confused with the domestic pig, *Sus domesticus*, at archaeological sites, although it was probably common throughout Scotland. With the loss of the forests and with the increase in hunting both for sport and meat, wild pigs probably became extinct in Scotland in the sixteenth or seventeenth century. This incomplete skull (B) is from the Soutra Hospital site in the Borders and dates to about AD 1300.

Eurasian beaver (*Castor fiber*): Remains of the beaver have been found in about ten localities in Scotland. A skull (C) was found under peat at Linton Loch in the Borders and has been radiocarbon dated to more than 7000 years old. Historical accounts suggest that the beaver may have persisted in Scotland until as late as the mid-sixteenth century, when it became extinct through being hunted for its fur, meat and a substance called castoreum (produced by a scent gland), which was used in medicines.

HISTORY OF THE FORESTS

FROM 6000 YEARS AGO

Disappearing forests

Since 6000 years ago the forests of Scotland have disappeared mainly as a result of human activities.

Early hunter-gatherers felled trees for fuel and to build temporary settlements, but they had little impact on Scotland's forests.

About 6000 years ago Neolithic farmers began to clear the forests to grow crops, and to provide browse (food) for domestic livestock, and building materials for more permanent settlements.

During the Bronze and Iron Ages (4500-2500 years ago) blanket bogs spread because of the cooler and wetter climate. This may also have been encouraged by the felling and burning of trees, and the land became less suitable for the regeneration of forest.

Continued felling of trees and grazing by domestic animals prevented natural regeneration, even where the soils and climate favoured this. As as result, most of the forest cover in Scotland was lost during this period, except in the Highlands.

In some areas the forest did regenerate, particularly during the first millennium AD, but since then the woodland has been generally in decline until the twentieth century.

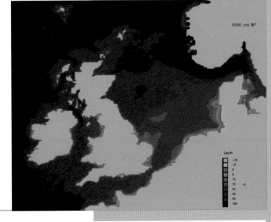

Map of the Middle Holocene Period, 6000 years ago. (University of Durham)

Holocene Period

- Britain becomes an island after the land bridge was inundated by rising sea levels.
- The climate is much warmer, even warmer than today.
- The land is covered by forests: pine woods in the Highlands and oak woods in the Lowlands.
- The forests have reached their peak of development, just prior to the arrival of farming.

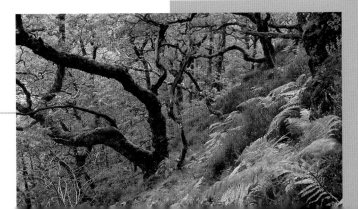

Oak woods dominated the Lowlands. (L Gill/SNH)

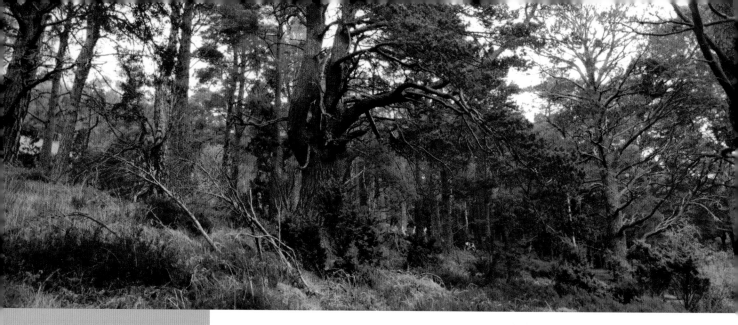

Locality map:

1 Prehistoric red deer
2 Modern red deer
3 Aurochs
4 Celtic ox

Rothiemurchus Forest near Aviemore, Inverness-shire, is one of the last areas of the Caledonian pine forest in Scotland. (N McLean/NMS)

Below: The Celtic ox was a small breed of the domestic cattle which was brought to Scotland. This example was found during excavations at the Roman camp at Newstead in 1846-47. (I Larner/NMS)

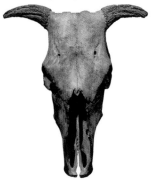

Changing habitats: changing size

Since the last Ice Age many mammals have decreased in body size. Over the last 6000 years forests have disappeared and the climate has cooled. This has left an environment which does not produce enough nutritious food during the spring and early summer for large mammals to reach their full potential for growth.

A domestic replacement

The native wild aurochs, *Bos primigenius*, was gradually replaced by imported domestic cattle, *B. taurus*, when Neolithic peoples arrived in Scotland 5800 years ago. Although the aurochs is the ancestor of domestic cattle, domestication actually occurred thousands of miles away in the Middle East.

The aurochs became extinct through hunting and habitat loss. In contrast, domestic cattle became more abundant as the habitat was changed to provide more grazing, browse and protection from predators.

The shrinking red deer

The red deer, *Cervus elaphus*, has declined dramatically in size over the last 9000 years. This probably worsened because of over-population in the second half of the twentieth century. In the 1990s there were more red deer in Scotland (350,000) than in the rest of Europe.

When Scottish red deer were introduced to New Zealand in the nineteenth century they grew much bigger, benefiting from a nutritionally rich environment and little competition.

Stowaways

Some animals arrived with people when farming began in Scotland. Domestic livestock was deliberately transported, but other species were stowaways on boats. Many rodents were accidentally introduced to islands where they have evolved into giants. It is believed that in the absence of ground predators (e.g. polecats, wildcats, etc.), island rodents are able to evolve a larger body size to withstand the rigours of living on islands.

The Orkney vole, *Microtus arvalis orcadensis*, was brought there by Neolithic farmers. Remains found in middens (rubbish heaps) at archaeological sites in the area show that it was in Orkney 5400 years ago. Its ancestor was the much smaller field vole from mainland Europe, which did not colonise Britain after the last Ice Age.

Above: A modern red deer skull from Loch a' Bhealaich on the Kintail Estate, Wester Ross, found in 1998, typical of most of the Scottish population today. (N McLean/NMS)

Above, right: These enormous antlers are from a red deer found under the roots of a tree on the Meadows in Edinburgh in 1782. They have been radiocarbon dated to 10,200 years old. (N McLean/NMS)

Right: Red deer stags today. (L Gill/SNH)

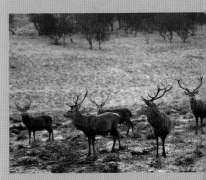

Below, right: Orkney vole, *Microtus arvalis orcadensis*, in nature. (NPL)

Far left: This aurochs skull was found in Hapsburn, Roxburghshire, and has been radiocarbon dated to *c.*8700 years old. (K Smith/NMS)

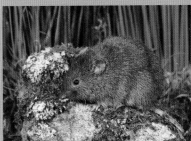

Bluebells,
Hyacinthoides non-scripta.
(M Sumega/NMS)

Long-horned beetle,
Rhagium bifasciatum.
(L Gill/SNH)

Left: Hoof fungus,
Fomes fomentarius.
(N McLean/NMS)

Right: Birch trees, Crathes,
Deeside, Aberdeenshire.
(L Taylor/NMS)

FORESTS TODAY

By the beginning of the twentieth century less than five per cent of Scotland was covered in forest. In 1990 fifteen per cent of Scotland was covered in forest, mainly through coniferous plantations planted mostly since 1945. However, plantation woodland, particularly of conifers, does not encourage a wide variety of wildlife.

Between the 1940s and the late 1980s the land area covered by plantations increased by about 700 per cent, but ancient and semi-natural woodland declined by 15 per cent and represents only about a quarter of all woodland today.

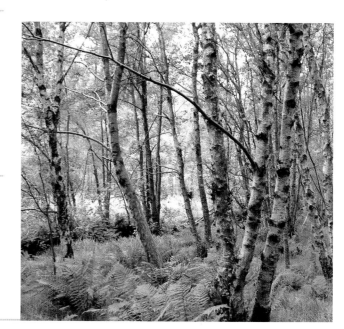

SCOTLAND'S NATURAL HERITAGE

THE BIODIVERSITY

One measure of biodiversity is the total number of species of plants, animals and micro-organisms found in a particular habitat or country. Scotland is home to an estimated 90,000 species. About 50,000 of these are found on the land and in fresh water, and the rest are found in the seas within about 19.3 kilometres (12 miles) of the coast.

For some groups of organisms (living things), such as mammals, birds and flowering plants, we know very accurately how many species there are in Scotland. However for other groups, such as insects, fungi and bacteria, we can only roughly estimate numbers of species.

Lifestyles

Although some of Scotland's species are found in a variety of habitats, many others are specialists which are confined to particular habitats. Many specialists are extremely demanding, so they occupy very narrow niches (ways of life) and particular microclimates within habitats.

Much more research is needed to find out how all these species interact with each other to sustain the biodiversity and maintain the environment of Scotland.

Pie chart showing the estimated number of species of living organisms found on the land and in the seas of Scotland:

- viruses (3300)
- bacteria (3300)
- protozoa (37,000)
- vertebrates (560)
- arthropods (18,675)
- other invertebrates (6136)
- plants (2008)
- algae (9000)
- fungi (9140)

Scotland's biodiversity

1. Chanterelle (a fungus), *Cantharellus cibarius.* (SNH)
2. Dog violets, *Viola riviniana.* (L Gill/SNH)
3. A wrack (seaweed), *Fucus* sp. (N McLean/NMS)

MADE IN SCOTLAND

ENDEMIC SPECIES

Only a few species of plant and animal are endemic (unique) to Scotland. This is largely because there has not been enough time for new species to evolve.

Much of the land was covered in ice during the last Ice Age. Very few species could survive these conditions and had to colonise from further south. The 11,750 years that have passed since the ice retreated have not been long enough for many new species to have evolved in Scotland, even though a large number of populations are now isolated here.

It is possible that research in the future may show that there are more endemic micro-organisms (which have very short intervals between generations), but as yet our knowledge is much too poor to assess this.

However, there are some truly endemic species, including the Scottish primrose, *Primula scotica*. It is confined to Orkney and the far north of mainland Scotland. As with many other plant species, it may have originated as a hybrid between two closely related species.

Above: Scottish primrose, *Primula scotica*. (SNH)

Distribution map of the Scottish primrose.

Right: Recent research has shown that the Scottish crossbill, *Loxia scotica*, is Scotland's only endemic bird species. Here is a male feeding in Scots pine. (NPL)

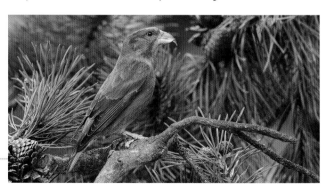

74

SCOTLAND'S NATURAL HERITAGE

THE HABITATS

Scotland's natural heritage comprises roughly 40 per cent land and 60 per cent sea. Each habitat group includes a number of different habitats, each of which has characteristic species of plants and animals adapted to particular environmental conditions.

The distribution and quality of all these habitats have changed over time, as we have already seen for the forests. Human activities have damaged or modified original habitats as the human-made environment has expanded. Many habitats require conservation, management and restoration to ensure the continued survival of the many thousands of species dependent on them.

Scotland is still home to a wide variety of habitats and species. Many of these are of conservation importance, both nationally and internationally. Scotland's natural heritage provides for recreation and tourism, and also forms the basis of important industries. This section takes a look at the wide diversity of habitats that are found in Scotland today.

Within Scotland's 81,570 square kilometres (31,494 square miles) of land and its much greater area of sea are various main habitat groups which include:

- Forests and woodlands
- Seas and shores
- Fresh water and wetlands
- Mountain and moorland
- Urban and farmland habitats

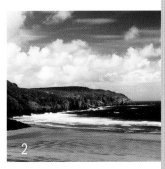

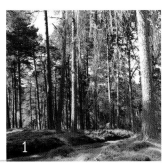

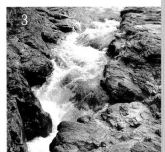

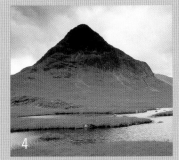

1 Caledonian pine forest. (L Taylor/NMS)
2 A sandy shore, Isle of Lewis. (N McLean/NMS)
3 Waterfall, Linn o' Dee, near Braemar. (L Taylor/NMS)
4 Montane habitat. (SNH)
5 Machair. (L Gill/SNH)

A serpulid worm,
Serpula vermicularis.
(S Scott/SNH)

Acorn barnacles,
Chthamalus stellatus.
(N McLean/NMS)

Rock pool, Birsay, Orkney.
(N McLean/NMS)

Humpback whale,
Megaptera novaeangliae.
(L Gill/SNH)

SEAS AND SHORES

Shallow seas and open oceans

Scotland's relatively unpolluted seas are mostly from 30 to 200 metres deep. About 370 kilometres from the west coast of Scotland the continental shelf falls away to some 5000 metres deep at the bottom of the Rockall Trough.

Shores

The combination of oxygen-rich cold northern waters and the warm North Atlantic Drift current means that many different species of animal and plant survive on Scotland's coasts and in its seas. It has been estimated that almost 40,000 species of animal, plant and micro-organism live in Scotland's seas.

Sand dunes on the Hebridean Isle of North Uist. (SNH)

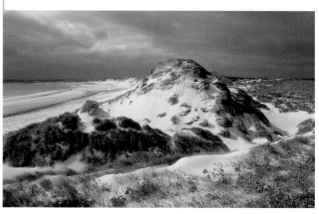

We still know relatively little about marine habitats, but surveys are being carried out to help us to understand them better.

Scotland's coastline is almost 12,000 kilometres long, including the almost 800 islands with land vegetation.

Scotland has a wide variety of coastal habitats including cliffs, caves, shores, lagoons, saltmarshes and sea lochs.

Estuaries

There are almost 50 estuaries, which channel the fresh water from the rivers to the seas. Their mudflats can support millions of marine invertebrates per square metre, which in turn support vast numbers of waders and other birds.

Pie chart showing proportions of different types of coastal habitat:

- muddy (2.4%)
- sandy (8.9%)
- rocky (48.1%)
- shingle (25.3%)
- mixed (10%)
- no intertidal (2.3%)
- saltmarsh (3%)

Coastal habitats

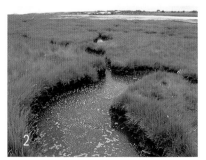

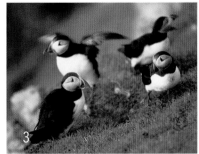

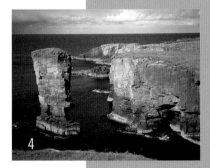

1 Forth Estuary mud-flats, Cramond. (N McLean/NMS)
2 Saltmarsh, Solway Firth. (SNH)
3 Puffins, *Fratercula arctica.* (SNH)
4 Yesnaby Castle, Orkney. (L Gill/SNH)

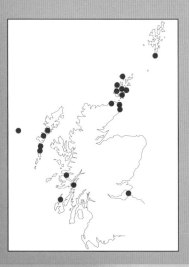

Archaeological sites where great auk bones have been found.

Below: Fowl Craig, Papa Westray, scene of the last nesting site of the great auk in the Orkney Islands. (N McLean/NMS)

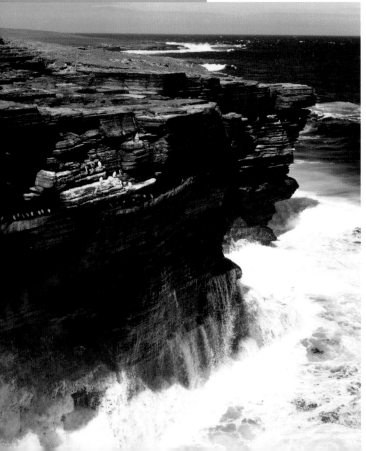

The great auk

The great auk, *Pinguinus impennis*, was a flightless seabird that was once very abundant in the North Atlantic. Exploitation by coastal communities for meat, fat and feathers caused its population to decline drastically. Finally, collecting of adults and eggs for private and museum collections led to its global extinction in 1844. The last Scottish bird was killed on St Kilda in 1840.

Prehistoric peoples left much evidence of what they had eaten in middens (rubbish heaps). The great auk is now extinct, but its bones have been found in middens in several parts of Scotland, showing that it was once a widespread bird. Remains which were found at Aikerness Broch, Orkney, are from at least four individual great auks. The sternum (breast bone) of one has distinct notches in it that were probably made by a bird of prey scavenging the carcass.

Below: Great auk. (K Smith/NMS)

INLAND WATER

FRESHWATER HABITATS

Scotland's 30,000 lochs and 6600 river systems hold 90 per cent of the fresh water in the United Kingdom. Most (97 per cent) of this is unpolluted, providing good freshwater habitats for a variety of invertebrates, plants and fish.

Two-thirds of Scotland's freshwater habitats are found in the West and North-East Highlands. They vary in size from small burns (streams) and ponds to large lochs and rivers. Altogether Scotland's river systems discharge 71 billion cubic metres of fresh water into the sea each year. This resource is one of Scotland's most valuable natural assets.

Scotland is renowned for its salmon angling, but the Atlantic salmon, *Salmo salar*, declined greatly during the second half of the twentieth century. Despite a long history of conservation legislation in Scotland, salmon stocks have suffered since the Industrial Revolution in the nineteenth century owing to a variety of problems. These include the effects of pollution, change of land use, water abstraction, acid rain, climate warming, over-fishing and genetic disruption caused by the release of farmed fish.

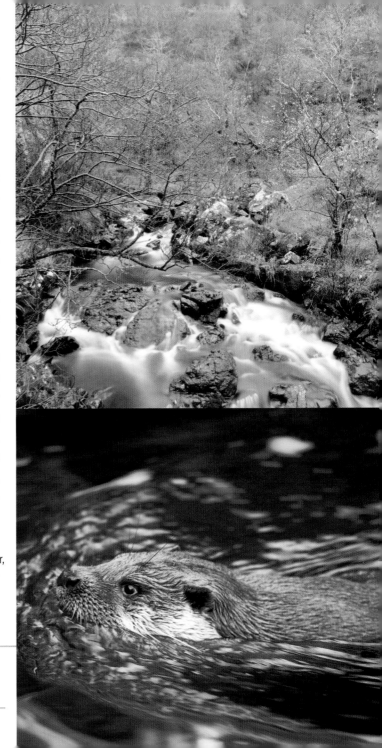

Above, right: Allander Water, near Milngavie, Dunbartonshire. (N McLean/NMS)

Right: Eurasian otter, *Lutra lutra.* (L Gill/SNH)

Left: White water lily, *Nymphaea alba.* (SNH)

INLAND WATER

WETLAND HABITATS

Wetlands make up more than 30 per cent of Scotland's land area. The high annual rainfall (averaging more than 1400 millimetres per year) means that Scotland is dominated by wetlands, many of which are of international importance as wildlife habitats.

There are two main types of wetland habitat: marshes and peatlands. Marshes are found at the edges of ponds and lochs, and form the transition to land. Peatlands develop in waterlogged areas where there is a lack of oxygen, which means that plant matter does not decay.

Above, left: Lesser reedmace, *Typha angustifolia*. (N McLean/NMS)

Left: Common frog, *Rana temporaria*. (L Campbell/SNH)

Right: White water lilies, Uath Lochan, Inshriach, Glenfeshie, Strathspey. (NPL)

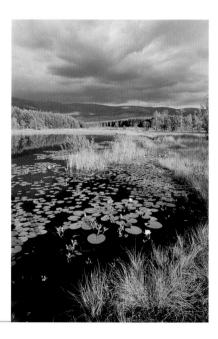

PEATLANDS

FENS AND BOGS

The two main kinds of peatland are fens and bogs. Fens are kept wet and fertile by mineral-rich ground water feeding into them. One of the most extensive fens in Scotland is the Insh Marshes near Aviemore, Inverness-shire.

Bogs derive their fresh water from rain and are normally poor in nutrients. There are two main kinds of bog: blanket bogs develop over large areas such as the Flow Country in Caithness and Sutherland, while raised bogs form domed islands of peat, particularly in lowland areas, such as Flanders Moss near Stirling.

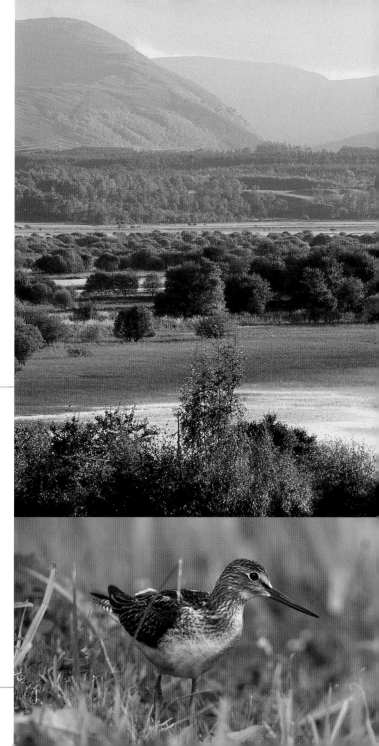

Right: The Insh Marshes, near Aviemore, Inverness-shire – actually a fen. (SNH)

Left: The large heath butterfly, *Coenonympha tullia scotica*, occurs in raised and blanket bogs in Scotland. (NPL)

Right: Greenshank, *Tringa nebularia*. (NPL)

Montane habitats

MOUNTAIN AND MOORLAND

1

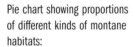

2

3

Pie chart showing proportions of different kinds of montane habitats:

- Matt-grass, *Nardus* snowbed (25%)
- Woolly fringe moss heath (24%)
- Montane heath (17%)
- Crowberry heath (8%)
- Montane blanket bog (6%)
- Others (5%)
- Human-modified habitats (15%)

1 Cairngorm Plateau. (N McLean/NMS)
2 Snow bunting, *Plectrophenax nivalis.* (SNH)
3 Crowberry, *Vaccinium vitis-idaea.* (L Gill/SNH)

Montane habitats

Montane habitats occur above the tree-line (where no trees can grow), which in most of Scotland is approximately 700 metres above sea level. These account for twelve per cent of Scotland's land area. Montane habitats have been mostly unaffected by human activities, but they are fragile and vulnerable to disturbance.

There are five main montane habitats in Scotland. Only 15 per cent of the total area has been affected by human activities. Each habitat is recognised by its community of plant species.

There are about 500 mountains that are more than 820 metres high. These provide important and mostly undisturbed wildlife habitats, including vital areas for relict Arctic and Alpine plants and animals.

The Cairngorm Plateau

At higher altitudes treeless habitats persist, where many plants maintain a fragile survival. On the Cairngorm Plateau many relict Arctic-alpine plants thrive, including trailing azalea (*Loiseleuria procumbens*), moss campion (*Silene acaulis*) and Alpine bearberry (*Arctostaphylos alpinus*). It is also the home of a relict bird, the ptarmigan, *Lagopus muta*, which is dependent on montane plants for food.

Moorland habitats

Moorland and related habitats cover more than 38 per cent of Scotland's land area and occur below the montane habitats and above the lowlands. Most of these were once wooded, but the trees have been cleared at different times in different areas over the last 6000 years.

Although affected by human activities, moorland habitats provide important breeding areas for many birds and support abundant populations of relatively few species of insect and spider.

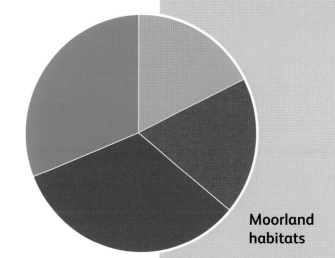

Moorland habitats

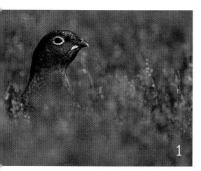

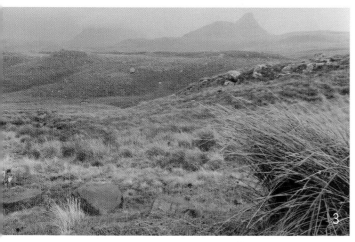

Pie chart (above) showing proportions of different kinds of moorland habitats:

- Heather moorland (18.4%)
- Peatland (17.8%)
- Mixed heather moorland and peatland (33.2%)
- Mixed rough grassland and moorland (30.6%)

1 Red grouse, *Lagopus lagopus scotica*. (SNH)
2 Lichen. (L Gill/SNH)
3 Assynt, Sutherland. (N McLean/NMS)
4 Heather, *Calluna vulgaris*. (L Taylor/NMS)
5 Blackface sheep, *Ovis aries*. (L Gill/SNH)

Farmland habitats

Farmland habitats

Pie chart (above) showing proportions of different kinds of farming:

- Rough grazing (69%)
- Improved grassland (19%)
- Arable (12%)

Main agricultural activities:

1 Wheat. (L Taylor/NMS)
2 Yellow machair. (SNH)
3 Hebridean sheep, *Ovis aries.* (N McLean/NMS)

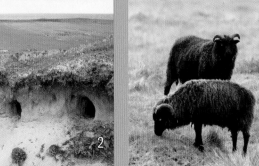

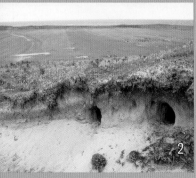

FARMS AND CITIES

URBAN AND FARMLAND HABITATS

Ever since people arrived in Scotland after the last Ice Age they have been altering natural habitats to suit their needs. At first the impact was minimal because numbers were small. There were only a few hunter-gatherers who moved around burning or clearing forest to create areas for temporary settlements, or possibly to promote the growth of grazing areas to attract game.

The first farmers arrived about 6000 years ago and had much more impact on natural habitats. About 78 per cent of Scotland's land area today is made up of human-made habitats.

Farmland habitats

More than 75 per cent (58,000 square kilometres) of Scotland's land area is used for agriculture. In general, Lowland areas, particularly in the east, support intensive arable and dairy farming, whereas much of the rest of Scotland is used for rough grazing, mainly by sheep.

Crofting is a system of mixed subsistence agriculture that takes place on only ten per cent of the agricultural land, mainly in the north and west of Scotland.

Although sustained through human management, agricultural habitats may be rich in wildlife. One of these is the machair system of grasslands, which is almost exclusive to the Western Isles. On coastal sandy soils that are rich in calcium carbonate from wind-blown broken sea shells, a unique grassland, rich in a wide variety of flowering plants, has developed on crofting land.

This low-intensity agriculture also benefits the corncrake, *Crex crex*. Elsewhere it has been almost exterminated by modern mechanised mowing methods which kill the chicks at harvest time. In spring corncrakes tend to be found hiding among the yellow irises, *Iris pseudacorus*, in the fen areas bordering the true machair where several species of orchid grow.

Urban habitats

Urban habitats cover less than three per cent of Scotland's land area, but 80 per cent of Scotland's people live in them. Between the 1940s and the late '80s built-up areas increased by more than 33 per cent throughout Scotland, the most dramatic increase being in Shetland (75 per cent) due to the development of the oil industry.

Urban habitats such as parks and gardens, including lakes and ponds, provide important refuges for many woodland and grassland species, such as sparrowhawks (*Accipiter nisus*), foxes (*Vulpes vulpes*) and badgers (*Meles meles*). Occasionally rare plants may also survive in industrial habitats that have particularly favourable characteristics. For example an orchid, Young's Helleborine (*Epipactis youngiana*), lives on two bings (spoil heaps) in Glasgow.

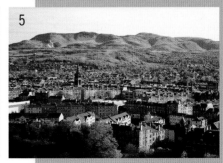

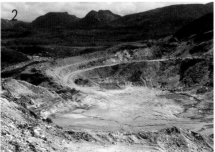

1 An urban garden. (SNH)
2 Quarry, Isle of Lewis. (N McLean/NMS)
3 Young's Helleborine, *Epipactis youngiana*. (J Wilson)
4 Garden snail, *Helix aspersa*. (SNH)
5 Housing estates and urban areas, Edinburgh. (M Sumega/NMS)

IS SCOTLAND'S WILDLIFE IMPORTANT?

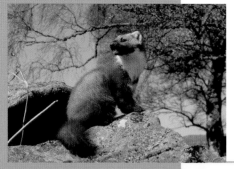

Pine marten,
Martes martes.
(L Gill/SNH)

Harebell, *Campanula rotundifolia.*
(L Taylor/NMS)

Hebridean spotted orchid, *Dactylorhiza fuchsii* ssp. *hebridensis.* (N McLean/NMS)

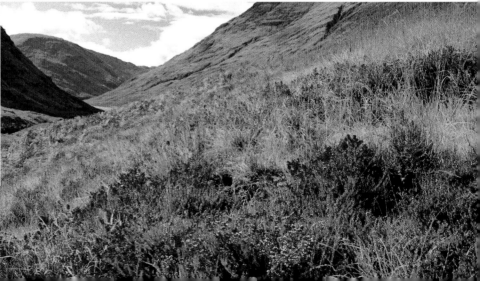

Although most habitats have been modified or degraded, much of the wildlife and many of the habitats of Scotland are of national and international importance, because of their rarity elsewhere. In recognition of this, 20 per cent of Scotland's land area is protected as National Parks, National Nature Reserves, Sites of Special Scientific Interest, and National Scenic Areas.

The wildlife and habitats of Scotland support many locally and nationally important industries, including forestry, peat extraction, fishing, shooting, leisure and tourism. For future generations to enjoy and benefit from the richness of Scotland's natural heritage, it will always be essential that we take the greatest care to protect this most precious resource.

PLACES AND WEBSITES TO VISIT

Some Places to Visit

Note: Please check opening hours and current availability before you visit, as exhibitions change and museums can be closed for renovation.

CROMARTY – Hugh Miller Museum
DUNDEE – University of Dundee Museum Services
EDINBURGH
– National Museum of Scotland (especially the *Beginnings* gallery, which shows many of the actual rocks, fossils and specimens which are evidence for the story in this book)
– Our Dynamic Earth
ELGIN – Elgin Museum
GLASGOW
– Hunterian Museum & Art Gallery
– Kelvingrove Art Gallery and Museum
– Fossil Grove, Victoria Park
HIGHLANDS – North-West Highlands Geopark

INVERNESS – Inverness Museum & Art Gallery
KILMARNOCK – The Dick Institute
MIDLOTHIAN – Scottish Mining Museum, Lady Victoria Colliery, Newtongrange
PERTH – Perth Museum and Art Gallery
WANLOCKHEAD – Museum of Lead Mining

Zoos, wildlife parks and aquaria often display native animals. The largest collections are at:

– Auchingarrich Wildlife Centre, Comrie
– Camperdown Wildlife Centre, Dundee
– Edinburgh Zoo
– Highland Wildlife Park, Kingussie
– Scottish Sea Life Sanctuary, near Oban
– Deep Sea World, North Queensferry
– St Andrews Aquarium

Websites to visit

National Museums Scotland
www.nms.ac.uk

Ordnance Survey (for maps)
www.ordnancesurvey.co.uk

Scottish geology
www.scottishgeology.com (main portal)
www.aberdeengeolsoc.co.uk
www.edinburghgeolsoc.org
www.geologyglasgow.org.uk

Scottish Museums Council (with listing of museums)
www.scottishmuseums.org.uk

British Geological Survey
www.bgs.ac.uk

Scottish Natural Heritage
www.snh.org.uk

SCRAN – Scottish history and culture, including some geology and scenery: www.scran.ac.uk

Acknowledgement

This book is based on the *Beginnings* exhibition in the National Museum of Scotland, Edinburgh. The authors are grateful to the many donors and lenders of the specimens illustrated here, and the people who gave them specialist advice. The authors thank Drs S Miller and L Anderson for review of the book in draft.

Collecting

For information about fossil and mineral collecting, and local societies and events, try Scottish Natural Heritage, Great Glen House, Leachkin Road, Inverness IV3 8NW; British Geological Survey, Murchison House, West Mains Road, Edinburgh EH9 3LA; your local museum, and the websites, shown on the previous page. Ask for a copy of the Code for Geological Fieldwork and the Scottish Fossil Code (due 2008) to help you collect safely and responsibly.

It is illegal to collect birds' eggs and to pick flowering plants. It is also illegal to kill or harm many species of plants and animals, which are protected under the Wildlife & Countryside Act, 1981. However, dead animal specimens often provide valuable information about species, which can contribute towards their conservation. If you find a dead animal in good condition on the road, or your cat brings home dead animals, please contact Dr Andrew Kitchener at National Museums Scotland.

No mammals or birds were killed deliberately for display or photography in the exhibition or book. All were natural casualties or were culled legally and humanely for other purposes.

BOOKS TO READ

Scottish geology and scenery

Geology and Landscapes of Scotland, C Gillen (Terra, 2003).

James Hutton: Founder of Modern Geology, D B McIntyre and A McKirdy (National Museums Scotland, 2001) (reprinted).

Land of Mountain and Flood. The Geology and Landforms of Scotland, A McKirdy, J Gordon and R Crofts (Birlinn and SNH, 2007).

Books in the *Landscape Fashioned by Geology* series published by Scottish Natural Heritage, including *Arran and the Clyde Islands*, *Ben Nevis and Glencoe*, *Cairngorms*, *East Lothian and the Borders*, *Edinburgh and West Lothian*, *Fife and Tayside*, *Glasgow and Ayrshire*, *Loch Lomond to Stirling*, *Mull and Iona*, *Northwest Highlands*, *Orkney and Shetland*, *Parallel Roads of Glen Roy*, *Rùm and the Small Isles*, *Scotland*, and *Skye*.

The Scenery of Scotland, W J Baird (NMS, 1990) (reprinted).

Scotland: The Creation of its Natural Landscape, A McKirdy and R Crofts (SNH, 1999).

Whisky on the Rocks, S Cribb and J Cribb (British Geological Survey, 1998).

See also regional field guides published by various geological societies in Scotland (see websites).

Geology, fossils and wildlife

Fossils – the story of life, S Rigby (BGS, 1997). And other titles by the BGS.

The Fossil Grove, A Gunning (Glasgow Museums, 1995).

Earth's Restless Surface, D Janson-Smith and G Cressey (Natural History Museum, 1996).

The Natural Heritage of Scotland. An overview, E C Mackey (SNH, 1995).

The nature of Scotland, M Magnusson and G White (eds) (Canongate: 1997), 2nd edition.

Books in the *Naturally Scottish* series published by Scottish Natural Heritage, including: *Amphibians & Reptiles*, *Badgers*, *Bumblebees*, *Burnet Moths*, *Butterflies*, *Corncrakes*, *Dragonflies & Damselflies*, *Fungi*, *Lichens*, *Mosses & Liverworts*, *Red Squirrels*, *River Runners*, *Sea Eagles*, *Seals*, and *Stoneworts*.

Books in the *Scotland's Living Landscapes* series published by Scottish Natural Heritage, including: *Grasslands*, *Kelp Forests*, *Mountains*, *Coasts*, *Firths*, *Machair*, *Sea Lochs*, *Soils*, and *Springs and Flushes*.

Species History in Scotland, R Lambert (ed) (Scottish Cultural Press, 1998).

The Birds of Scotland, R W Forrester (*et al.*) (The SOC, 2007).

For children

Scottish Landscapes, A McKirdy and M McKirdy (NMS, 1995) (reprinted).

Scottish Rocks and Fossils, A McKirdy and M McKirdy (NMS, 2010).

Books on rocks, fossils and natural history in general published by Dorling Kindersley.

For full listing of NMS Enterprises Limited – Publishing titles and related merchandise:

www.nms.ac.uk/books